More HOW TO DRAW MANGA

MANGA

Vol. 2

Penning Characters

MORE HOW TO DRAW MANGA Vol. 2: Penning Characters
by Go Office

Copyright © 2002 Go Office
Copyright © 2002 Graphic-sha Publishing Co., Ltd.

This book was first designed and published by Graphic-sha Publishing Co., Ltd. in Japan in 2002.
This English edition was published by Graphic-sha Publishing Co., Ltd. in Japan in 2004.

Artwork and Production:	Kazuaki Morita, Yumiko Deguchi, Hiroko Shioda, Ushio, Takehiko Matsumoto, Hikaru Hagi Gekko, Akira Gokita, Kozue Onishi, Haruto, Hitoshi Sato, BeE, Kento Shimazaki, Rio Yagizawa
Production Assistant:	Takumi Takahashi, Kozue Onishi
Production Support:	Julie Asakura
Cover Artwork:	Kazuaki Morita
English Main Title Logo Design:	Hideyuki Amemura
Composition and Text:	Hikaru Hayashi, Rio Yagizawa (Go Office)
Reference Photography:	Yasuo Imai
English Edition Layout:	Shinichi Ishioka
English Translation Management:	Língua fránca, Inc. (an3y-skmt@asahi-net.or.jp)
Planning Editor:	Motofumi Nakanishi (Graphic-sha Publishing Co., Ltd.)
Foreign Language Edition Project Coordinator: Kumiko Sakamoto (Graphic-sha Publishing Co., Ltd.)	

Distributor:
Japan Publications Trading Co., Ltd.
1-2-1 Sarugaku-cho, Chiyoda-ku, Tokyo, 101-0064
Telephone: +81(0)3-3292-3751 Fax: +81(0)3-3292-0410
E-mail: jpt@jptco.co.jp
URL: http://www.jptco.co.jp/

First printing: March 2004

ISBN 4-7661-1483-3
Printed and bound in China

More HOW TO DRAW MANGA

Vol. 2
Penning Characters

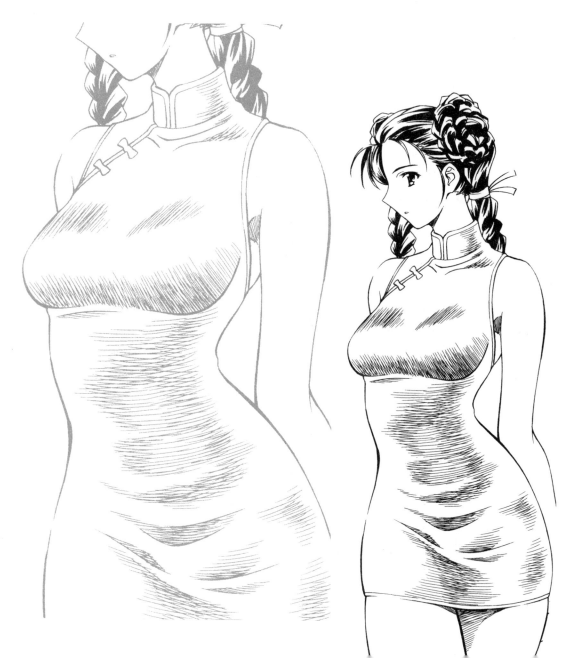

Table of Contents

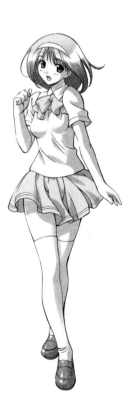

Chapter 3
Facial Expressions

Chapter 4
Manga Miscellaneous

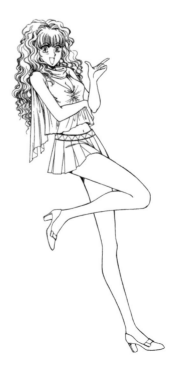

The Basic *Manga*-drawing Process: From Beginning to End

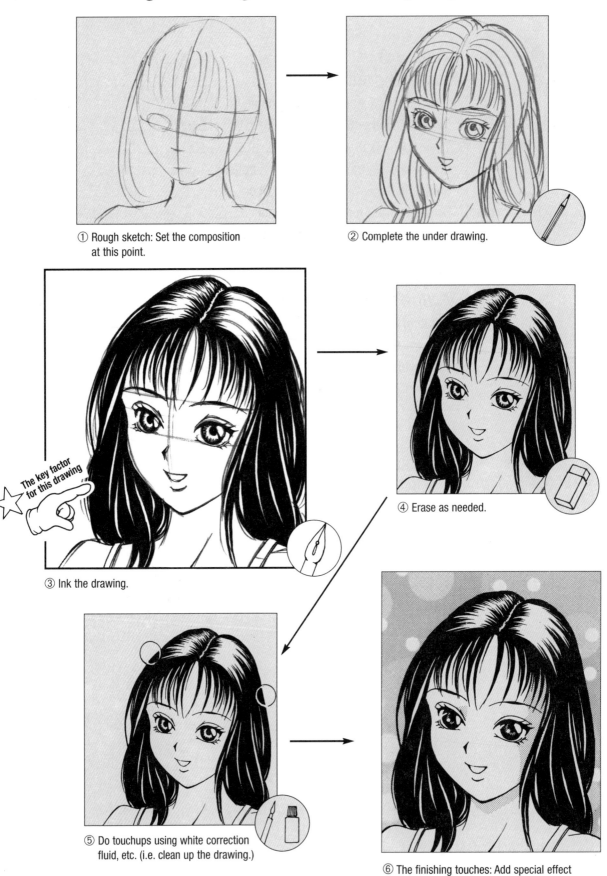

① Rough sketch: Set the composition at this point.

② Complete the under drawing.

The key factor for this drawing

③ Ink the drawing.

④ Erase as needed.

⑤ Do touchups using white correction fluid, etc. (i.e. clean up the drawing.)

⑥ The finishing touches: Add special effect lines and screen tone.

Chapter 1

Pen Fundamentals

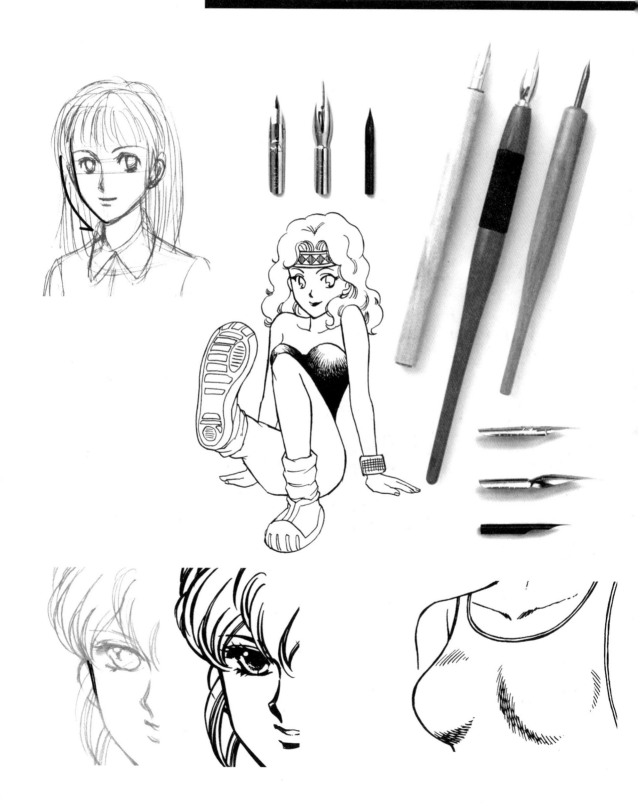

The Key Ingredient to *Manga* and Illustrations is Inking.

Under drawing

Finish using ink only (Realism *manga* style)

The clear, distinct black strokes of a pen breathe life into penciled drawings.

A sense of speed is generated using diagonal strokes.

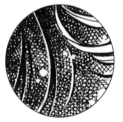

A gradation effect is created using *kakeami* (crosshatching).

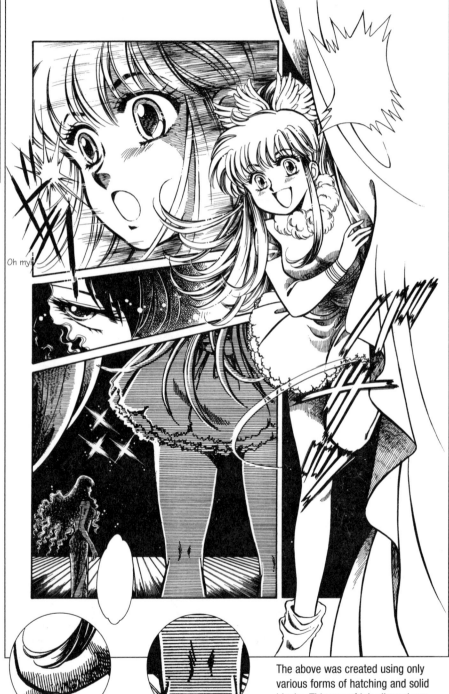

Oh my!

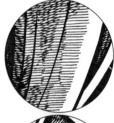

Shading and fabric can be suggested depending on how diagonal hatching is used.

Hatching suggests flesh.

Uniform, parallel, ruled lines create a shading, almost silhouette-like effect.

The above was created using only various forms of hatching and solid blacks. This use of ink allowed me to create a soft overall look, while projecting an intense atmosphere.

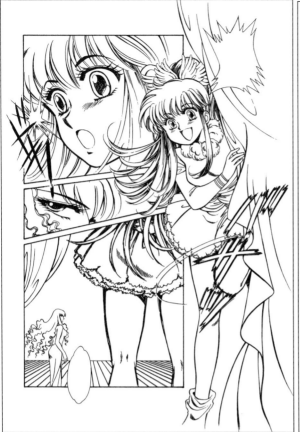

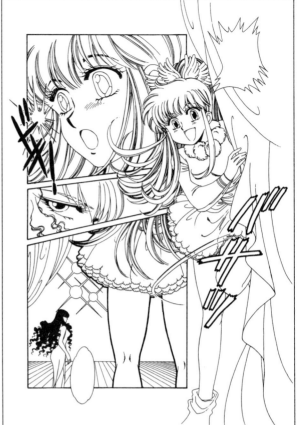

I drew this version anticipating that I would use only various forms of hatching and solid blacks for the final image. I rendered the subjects using powerful, heavy, modulated lines for silhouette lines. Jagged sound effect lettering allows for the creation of an intense mood.

I drew this version anticipating that I would use screen tone for the final image. With the exception of the final panel, where perspective is stressed, the overall page is rendered primarily using fine, even lines. Since the final image will have a lighter feel, I used more simplified style of sound effect lettering.

Penciled drawing
(Under drawing)

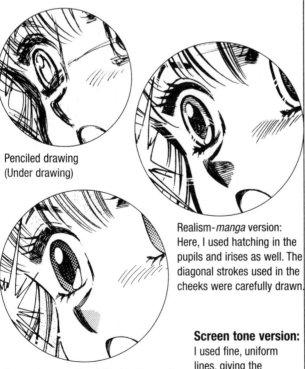

Realism-*manga* version: Here, I used hatching in the pupils and irises as well. The diagonal strokes used in the cheeks were carefully drawn.

Screen tone version:
I used fine, uniform lines, giving the composition a clean, light look.

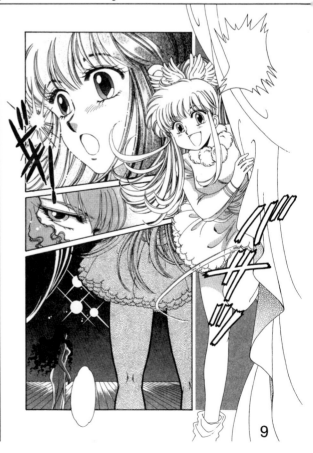

Screen tone version: I filled in the pupils using solid black and then attached gradation tone. The diagonal strokes used in the cheeks are less concentrated than those in the realism-*manga* version.

9

Inking Tools and Materials

Pens

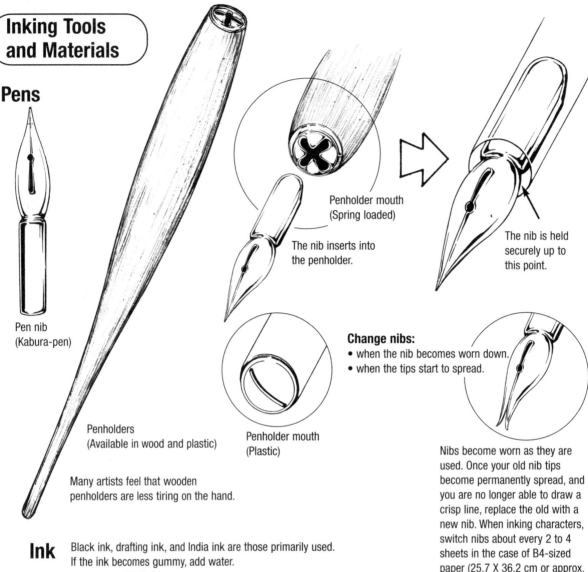

Pen nib
(Kabura-pen)

Penholder mouth
(Spring loaded)

The nib inserts into
the penholder.

The nib is held
securely up to
this point.

Penholders
(Available in wood and plastic)

Penholder mouth
(Plastic)

Many artists feel that wooden
penholders are less tiring on the hand.

Change nibs:
• when the nib becomes worn down.
• when the tips start to spread.

Nibs become worn as they are
used. Once your old nib tips
become permanently spread, and
you are no longer able to draw a
crisp line, replace the old with a
new nib. When inking characters,
switch nibs about every 2 to 4
sheets in the case of B4-sized
paper (25.7 X 36.2 cm or approx.
10" X 14 1/4").

Ink

Black ink, drafting ink, and India ink are those primarily used.
If the ink becomes gummy, add water.

The advantage of
drafting ink is that
it dries quickly.

While India ink does take
longer to dry than drafting
ink, it gives a "blacker"
finish.

Black or drafting ink

India Ink

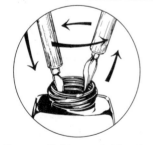

If you applied too much ink to the nib,
lightly wipe it on the ink jar's rim
(otherwise, you could end up with drops
of ink on your drawing).

Paper

• B4 is the standard size for publication
 submissions.

• Top quality paper (110 kg to 135 kg per
 1000 sheets or 121 lbs to 148.5 lbs per
 ream) or Kent paper is used.

• *Manga* drawing paper with predrawn
 margin lines, which are available on the
 market, may also be used.

• Use paper of a size that will allow a margin
 around the entire drawing.

Note: since the *manga* process involves penciling
an under drawing, inking, attaching tone, and other
work, most artists use large, durable paper.

Pen Nibs The 3 Most Common Nibs: The Kabura-pen, the G-pen, and the Maru-pen

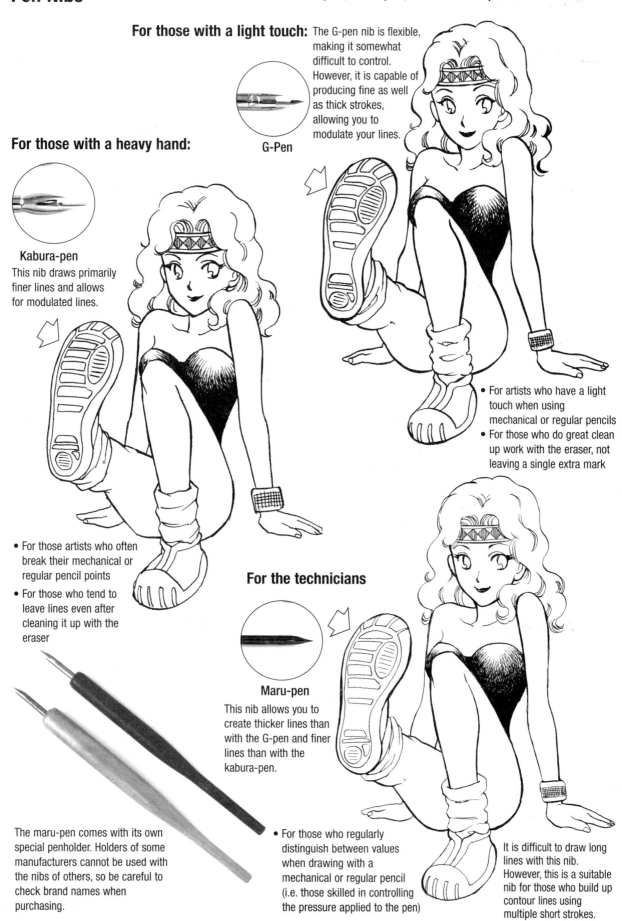

For those with a light touch:

The G-pen nib is flexible, making it somewhat difficult to control. However, it is capable of producing fine as well as thick strokes, allowing you to modulate your lines.

G-Pen

For those with a heavy hand:

Kabura-pen

This nib draws primarily finer lines and allows for modulated lines.

- For those artists who often break their mechanical or regular pencil points
- For those who tend to leave lines even after cleaning it up with the eraser

- For artists who have a light touch when using mechanical or regular pencils
- For those who do great clean up work with the eraser, not leaving a single extra mark

For the technicians

Maru-pen

This nib allows you to create thicker lines than with the G-pen and finer lines than with the kabura-pen.

The maru-pen comes with its own special penholder. Holders of some manufacturers cannot be used with the nibs of others, so be careful to check brand names when purchasing.

- For those who regularly distinguish between values when drawing with a mechanical or regular pencil (i.e. those skilled in controlling the pressure applied to the pen)

It is difficult to draw long lines with this nib. However, this is a suitable nib for those who build up contour lines using multiple short strokes.

How to Ink

Note that the pen is held differently from when writing.

1 Holding the Pen: Hold the Pen Closer to the Paper When Inking

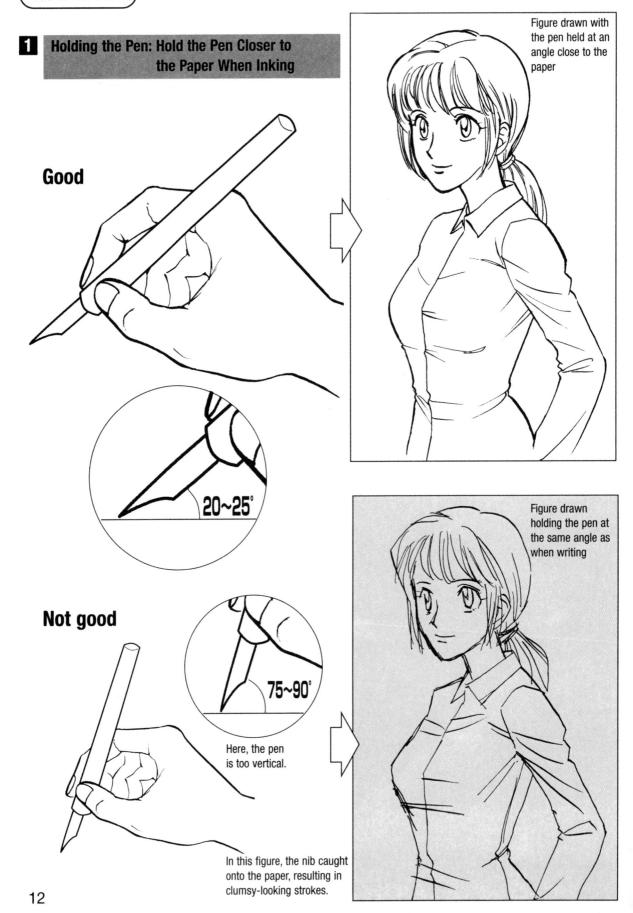

Good

20~25°

Figure drawn with the pen held at an angle close to the paper

Not good

75~90°

Here, the pen is too vertical.

In this figure, the nib caught onto the paper, resulting in clumsy-looking strokes.

Figure drawn holding the pen at the same angle as when writing

12

2 The Inking Process: Rotate the Paper While Inking

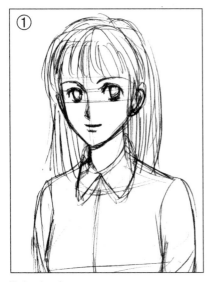

①

Under drawing

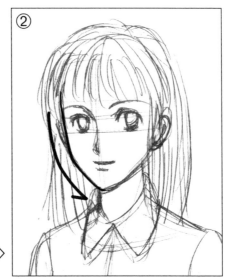

②

Normally, artists start with the face contours and work from there.

③

Shift the paper to an angle that allows you to ink more easily.

④

Return the paper to its original position when inking the shoulders. Constantly rotate the paper to the most comfortable position when inking. An artist rarely inks an entire drawing without moving the paper.

The same holds true when drawing hair standing on end.

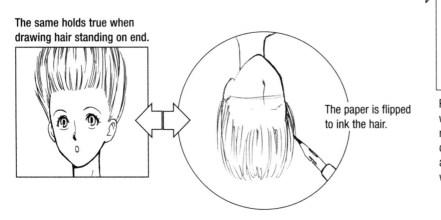

The paper is flipped to ink the hair.

Inking Theory: Common Lines

1 The Basics: Even and Tapered Lines

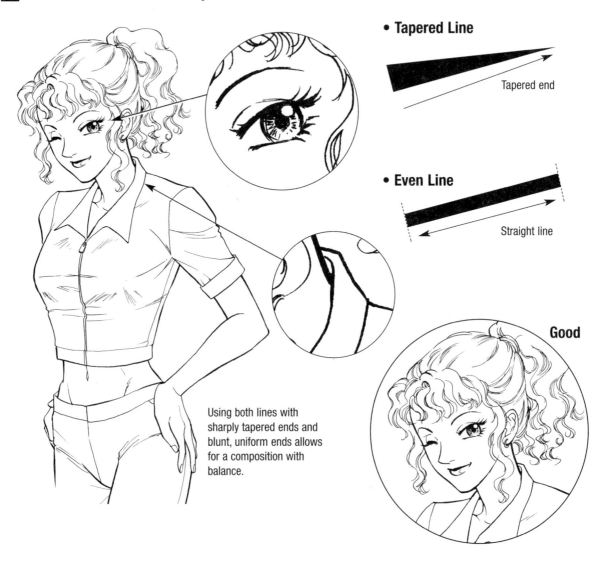

- **Tapered Line**

Tapered end

- **Even Line**

Straight line

Using both lines with sharply tapered ends and blunt, uniform ends allows for a composition with balance.

Good

Figure Drawn Entirely with Tapered Lines

Not good

While this drawing does have vigor, it has a diffuse, disorderly look.

Figure Drawn Entirely with Even Lines

Not good

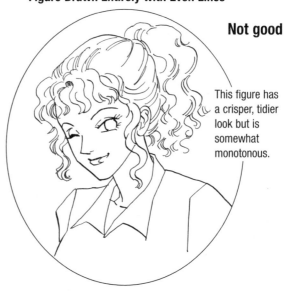

This figure has a crisper, tidier look but is somewhat monotonous.

Making the Most of Tapered and Even Lines: Drawing Nudes
Tapered lines are key to giving the flesh volume.

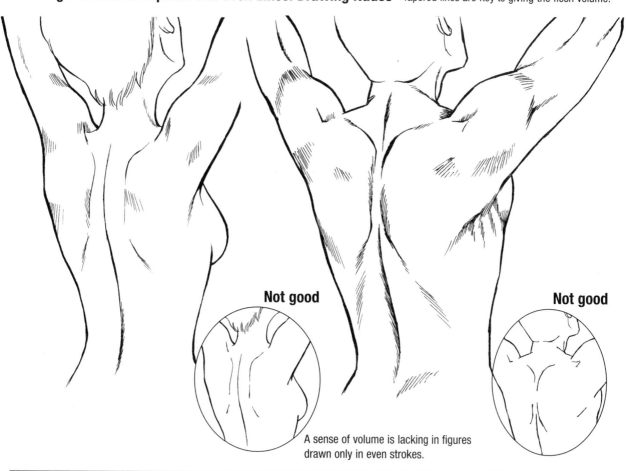

Not good

Not good

A sense of volume is lacking in figures
drawn only in even strokes.

Drawing Tapered Lines

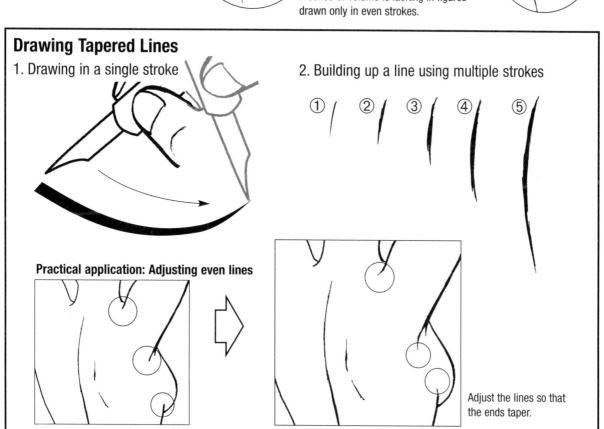

1. Drawing in a single stroke

2. Building up a line using multiple strokes

① ② ③ ④ ⑤

Practical application: Adjusting even lines

Adjust the lines so that
the ends taper.

2 Using Heavy and Fine Lines (Balancing Heavy and Light Areas)

Make contour and silhouette lines heavier than those in the interior.

Heavy line

These lines are finer than the contour line.

Balance your line usage even in small compositions.

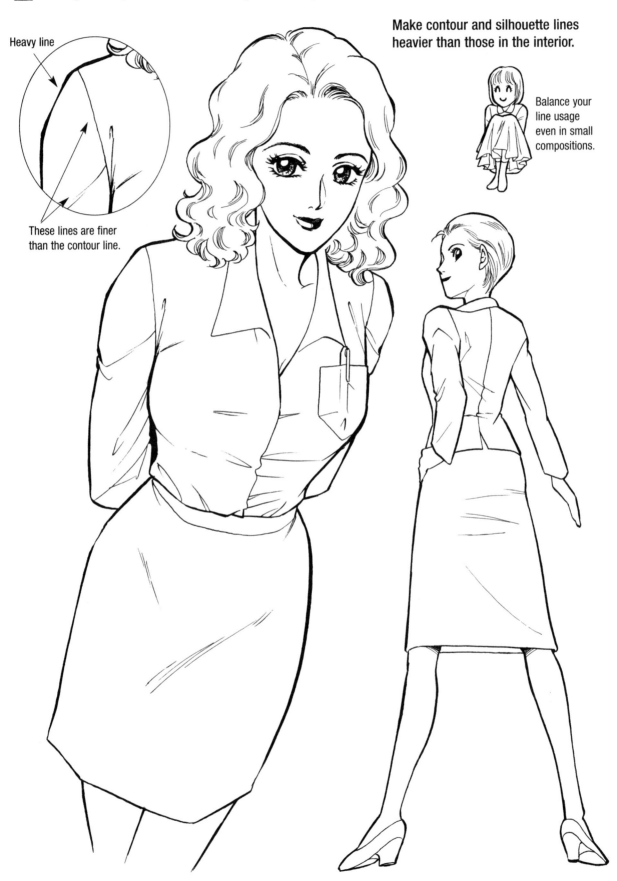

Assorted Uses of Heavy and Fine Lines

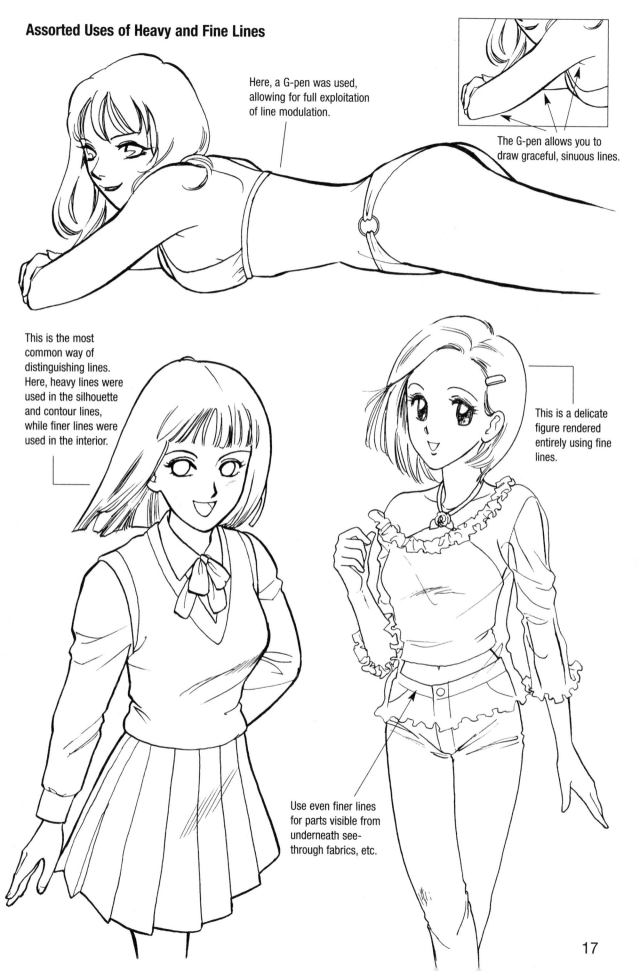

Here, a G-pen was used, allowing for full exploitation of line modulation.

The G-pen allows you to draw graceful, sinuous lines.

This is the most common way of distinguishing lines. Here, heavy lines were used in the silhouette and contour lines, while finer lines were used in the interior.

This is a delicate figure rendered entirely using fine lines.

Use even finer lines for parts visible from underneath see-through fabrics, etc.

Modulating Lines: Building up Lines to Produce a Satisfying Composition

1. Building up those areas requiring heavier lines after first doing an even inking

Inking is not something that has to be done in one fell swoop. Once you have done a simple first inking of the entire composition, go over it again, creating a balance between heavy and fine lines and gradually building up contours and silhouette lines using many short strokes.

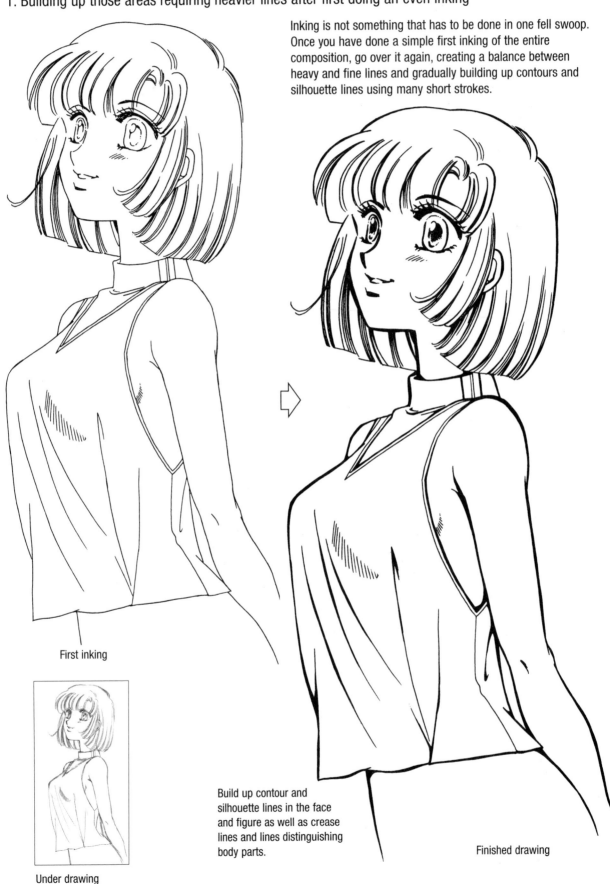

First inking

Build up contour and silhouette lines in the face and figure as well as crease lines and lines distinguishing body parts.

Finished drawing

Under drawing

2. Building up lines right from the start

This technique involves using the pen in much the same manner as you would the pencil. It is effective when the final is to be a reduction of the original (reducing drawings causes the individual strokes to come closer together, making the execution appear smoother).

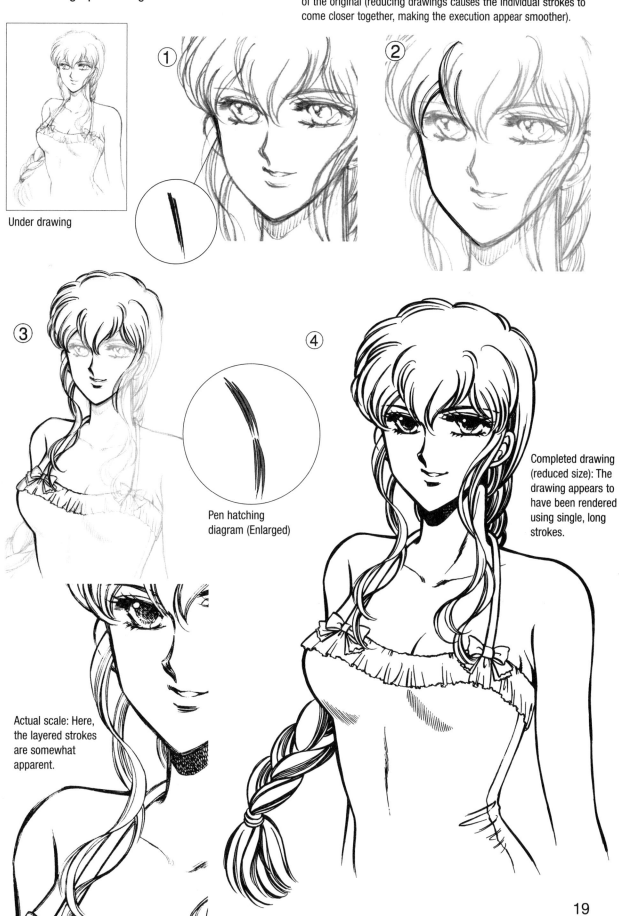

Under drawing

①

②

③

Pen hatching diagram (Enlarged)

④

Completed drawing (reduced size): The drawing appears to have been rendered using single, long strokes.

Actual scale: Here, the layered strokes are somewhat apparent.

3 Mastering Hatching, Etc.

Hatching basically consists of short, tapered lines drawn freehand. Longer versions become diagonal lines. Hatching adds spice to the inking job and is a finishing technique used in artwork.

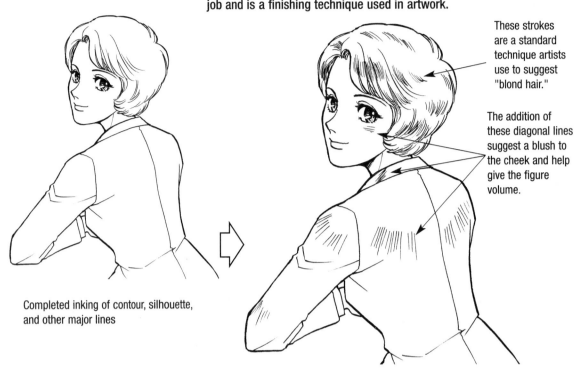

Completed inking of contour, silhouette, and other major lines

These strokes are a standard technique artists use to suggest "blond hair."

The addition of these diagonal lines suggest a blush to the cheek and help give the figure volume.

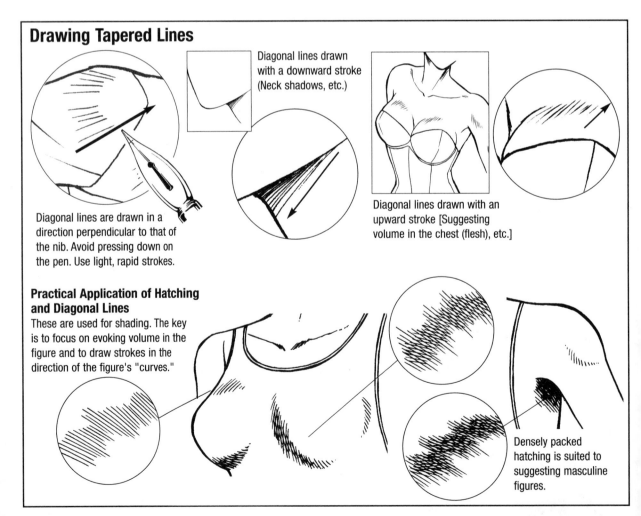

Drawing Tapered Lines

Diagonal lines are drawn in a direction perpendicular to that of the nib. Avoid pressing down on the pen. Use light, rapid strokes.

Diagonal lines drawn with a downward stroke (Neck shadows, etc.)

Diagonal lines drawn with an upward stroke [Suggesting volume in the chest (flesh), etc.]

Practical Application of Hatching and Diagonal Lines

These are used for shading. The key is to focus on evoking volume in the figure and to draw strokes in the direction of the figure's "curves."

Densely packed hatching is suited to suggesting masculine figures.

Chapter 2
Making Characters Distinctive

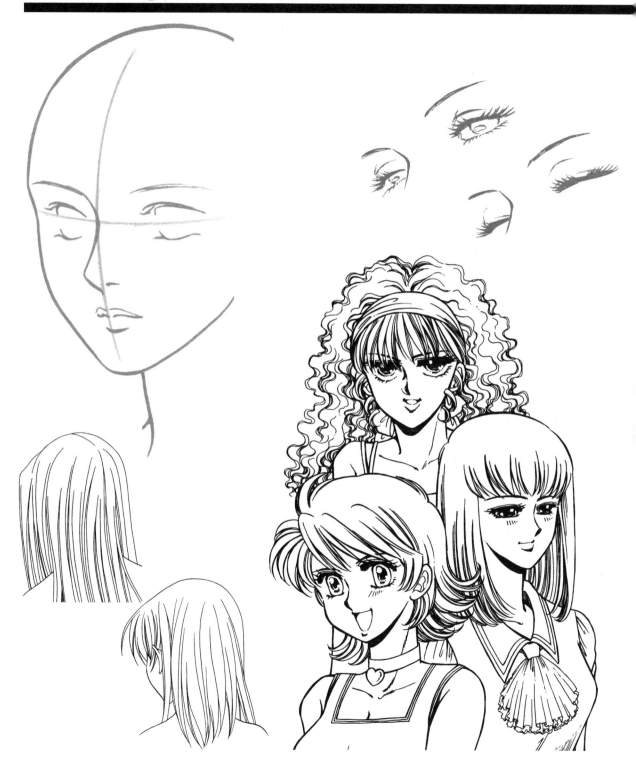

5 Basic Faces
5 Common Faces Used for Close-ups

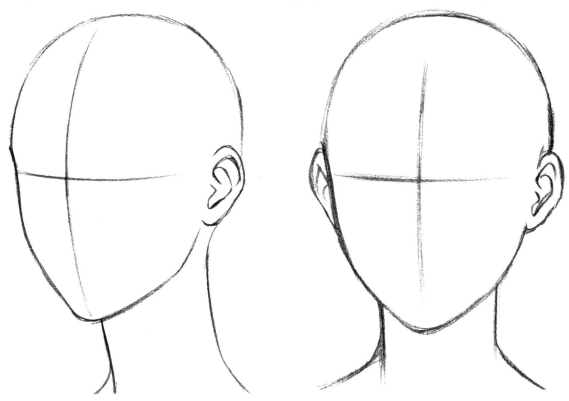

1. Face Turned to the Right (3/4 View) **2. Front View**

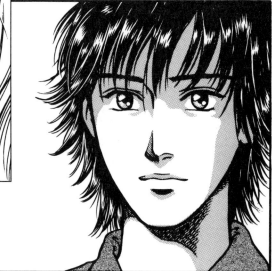

The 3/4 view and front view are primarily used when the character makes his or her appearance on the scene or when the artist wants to show the character's face.

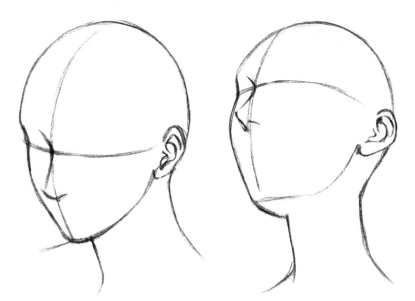

3. Side View

Often used for characters when speaking alone or engaged in conversation

4. Moderate High Angl

Primarily used in dialogue scenes

5. Moderate Low Angle

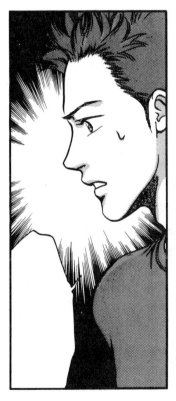

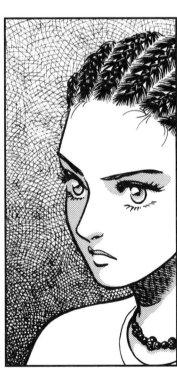

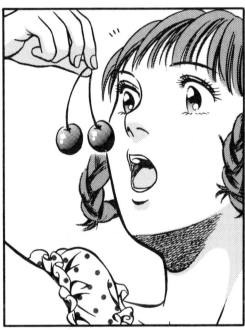

This view is effective when intending to give movement or variety to the composition, or give a character's depiction impact.

The main differences between this view and the standard 3/4 view and the points that you, the artist, must show the most care are the extent to which the crown is shown and the nose's angle.

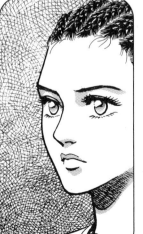

Standard 3/4 view

1. 3/4 View

Approximately the same distance

Slightly larger than the right eye

Even when not intending to keep the bridge of the nose in the final drawing, including the bridge in the under drawing will help you balance the eyes.

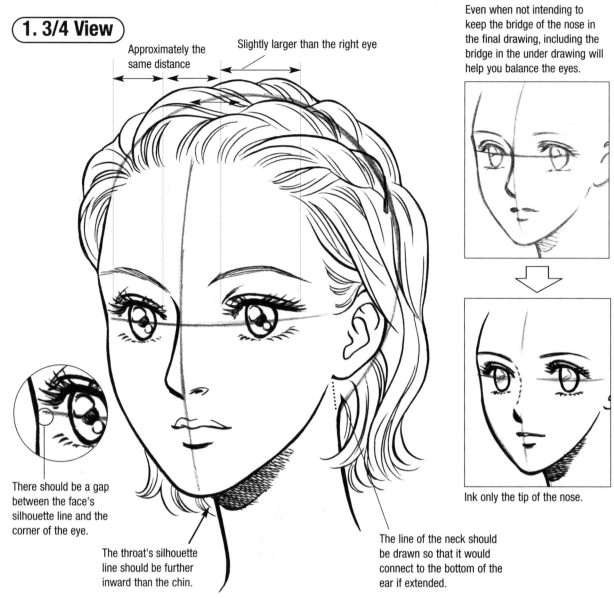

There should be a gap between the face's silhouette line and the corner of the eye.

The throat's silhouette line should be further inward than the chin.

The line of the neck should be drawn so that it would connect to the bottom of the ear if extended.

Ink only the tip of the nose.

2 Standard Styles for Rendering the Nose

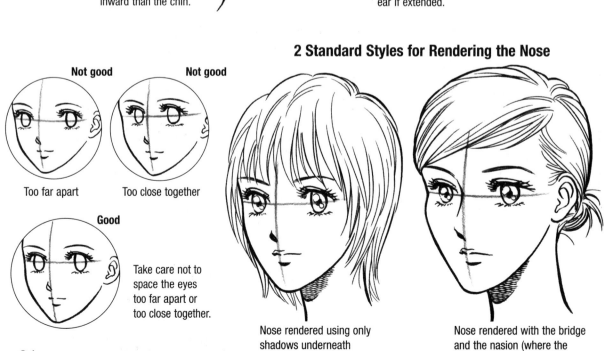

Not good

Not good

Too far apart

Too close together

Good

Take care not to space the eyes too far apart or too close together.

Nose rendered using only shadows underneath

Nose rendered with the bridge and the nasion (where the bridge meets the eyes)

Positioning the Figure with a 3/4 View Head

- Common poses showing the throat's silhouette line further inward than the chin

There are standard positions for the torso (i.e. from the neck down) used with each of the 5 head views. Since how the torso and neck connect depends on in which direction the torso is faced, I have compiled a few common samples for you.

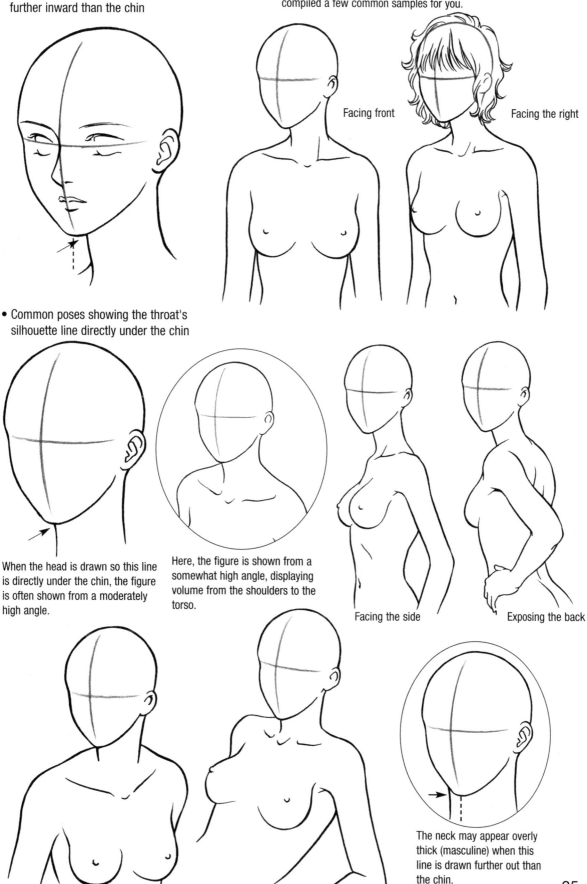

Facing front

Facing the right

- Common poses showing the throat's silhouette line directly under the chin

When the head is drawn so this line is directly under the chin, the figure is often shown from a moderately high angle.

Here, the figure is shown from a somewhat high angle, displaying volume from the shoulders to the torso.

Facing the side

Exposing the back

The neck may appear overly thick (masculine) when this line is drawn further out than the chin.

25

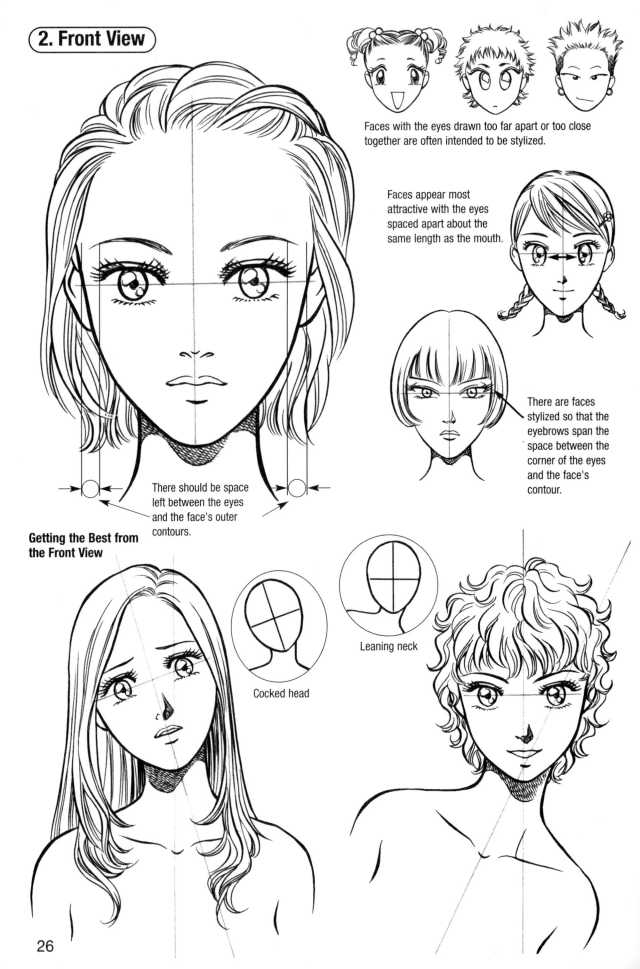

2. Front View

Faces with the eyes drawn too far apart or too close together are often intended to be stylized.

Faces appear most attractive with the eyes spaced apart about the same length as the mouth.

There are faces stylized so that the eyebrows span the space between the corner of the eyes and the face's contour.

There should be space left between the eyes and the face's outer contours.

Getting the Best from the Front View

Cocked head

Leaning neck

Front Views Effective in Manga

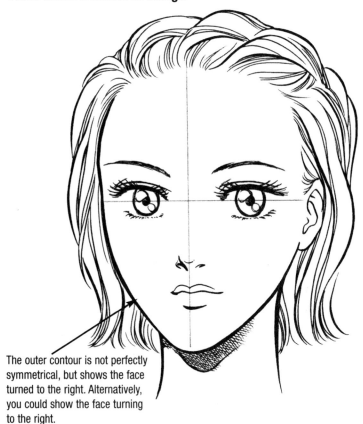

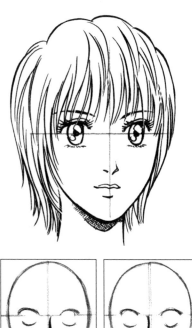

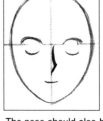
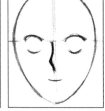

The outer contour is not perfectly symmetrical, but shows the face turned to the right. Alternatively, you could show the face turning to the right.

The nose should also be drawn facing either right or left with the head.

Assorted Noses for Front Views

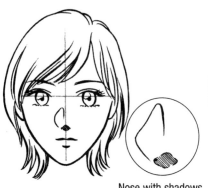

Nose with shadows underneath

Nose with shadows under one side

Nose with shadows on the side

Neck Girths

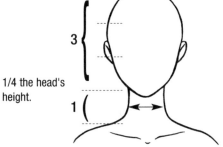

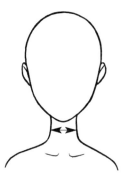

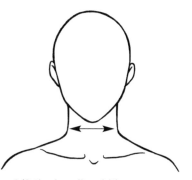

1/4 the head's height.

3

1

1/2 the head's width
Appropriate for female characters

1/3 the head's width
Appropriate for stylized, *manga*-esque characters

2/3 the head's width
Appropriate for realistic characters and characters with naturally thick necks (i.e. male characters)

Positioning the Figure with a Front View Head

A frontal view of the face allows the character to connect strongly with the reader. It is often used with the full figure.

Regular Angle

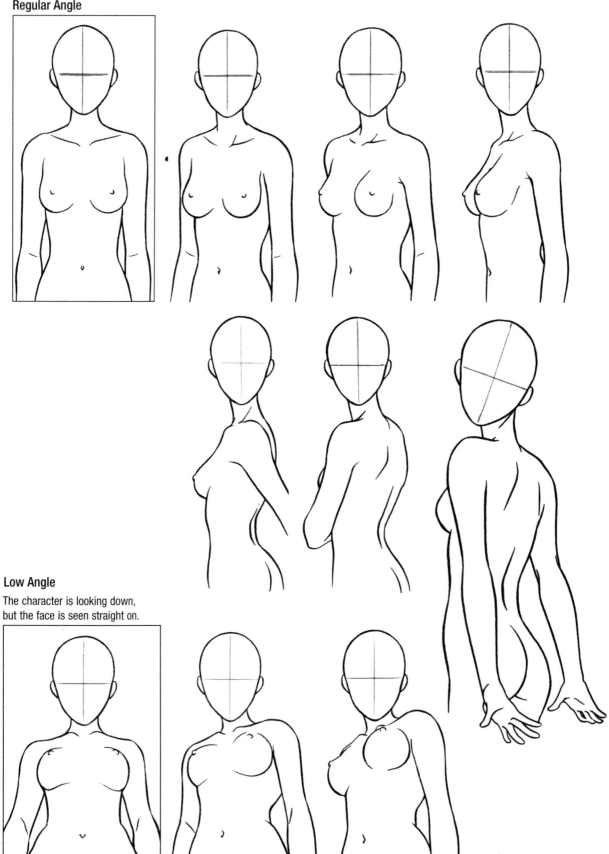

Low Angle

The character is looking down, but the face is seen straight on.

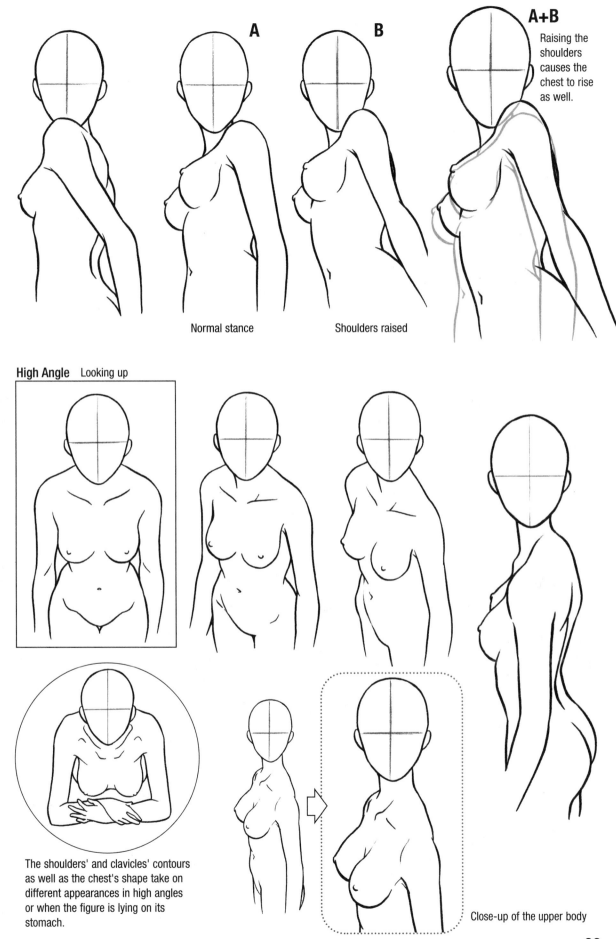

A

B

A+B
Raising the shoulders causes the chest to rise as well.

Normal stance

Shoulders raised

High Angle Looking up

The shoulders' and clavicles' contours as well as the chest's shape take on different appearances in high angles or when the figure is lying on its stomach.

Close-up of the upper body

29

Practical Application Sample

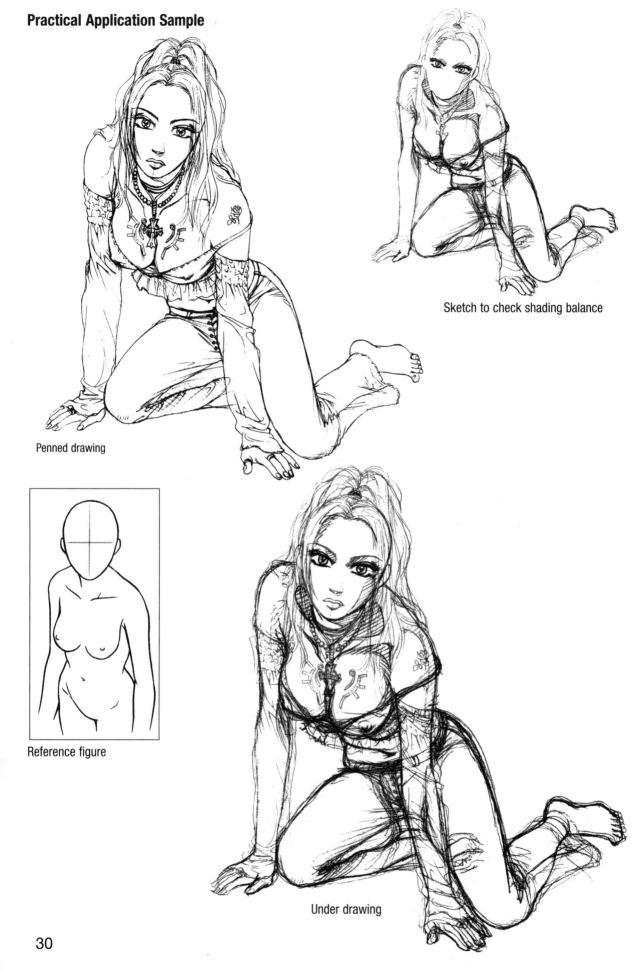

Sketch to check shading balance

Penned drawing

Reference figure

Under drawing

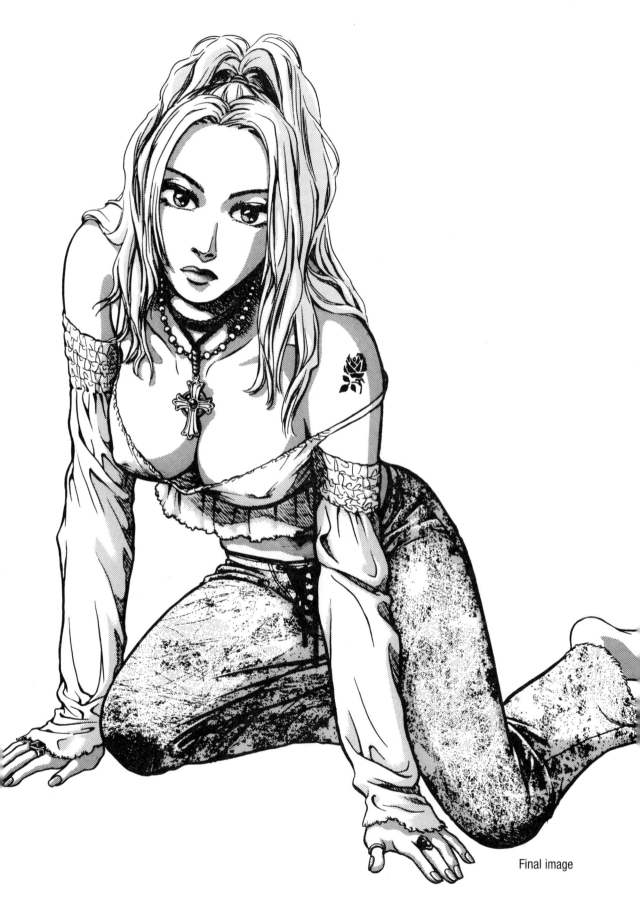
Final image

3. Side View

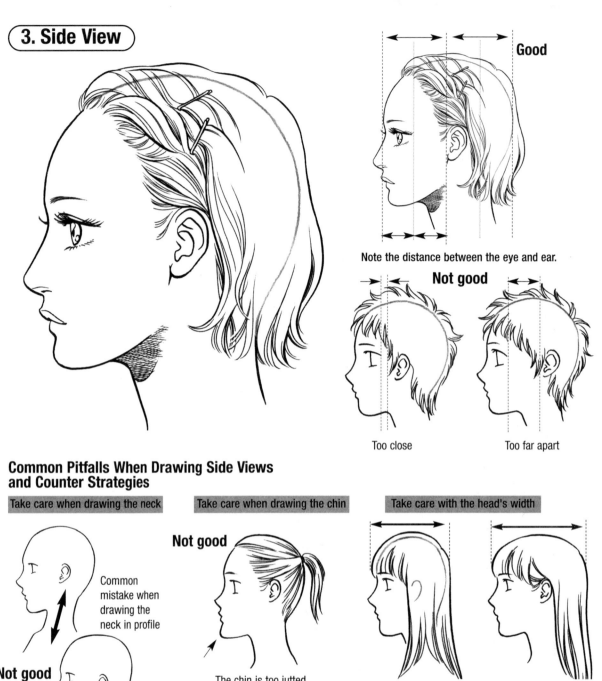

Note the distance between the eye and ear.

Good

Not good

Too close Too far apart

Common Pitfalls When Drawing Side Views and Counter Strategies

Take care when drawing the neck

Take care when drawing the chin

Take care with the head's width

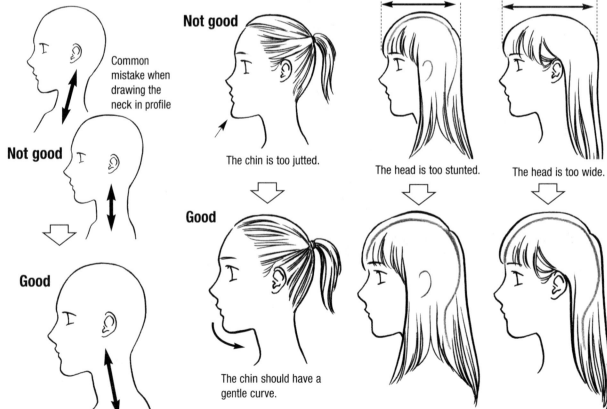

Common mistake when drawing the neck in profile

Not good

Good

Not good

The chin is too jutted.

Good

The chin should have a gentle curve.

The head is too stunted.

The head is too wide.

Positioning the Figure with a Side View Head

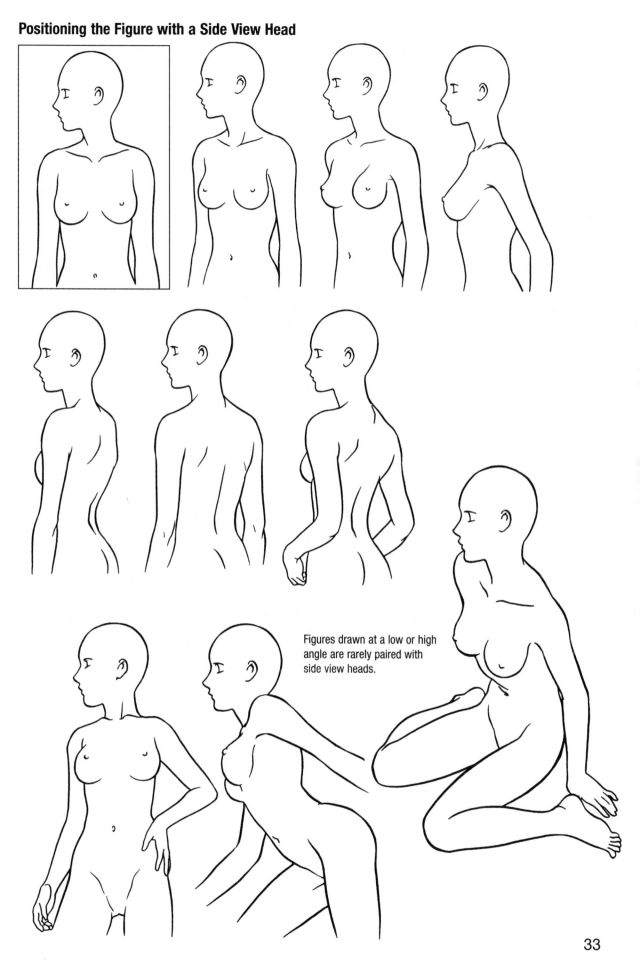

Figures drawn at a low or high angle are rarely paired with side view heads.

4. Moderate High Angle

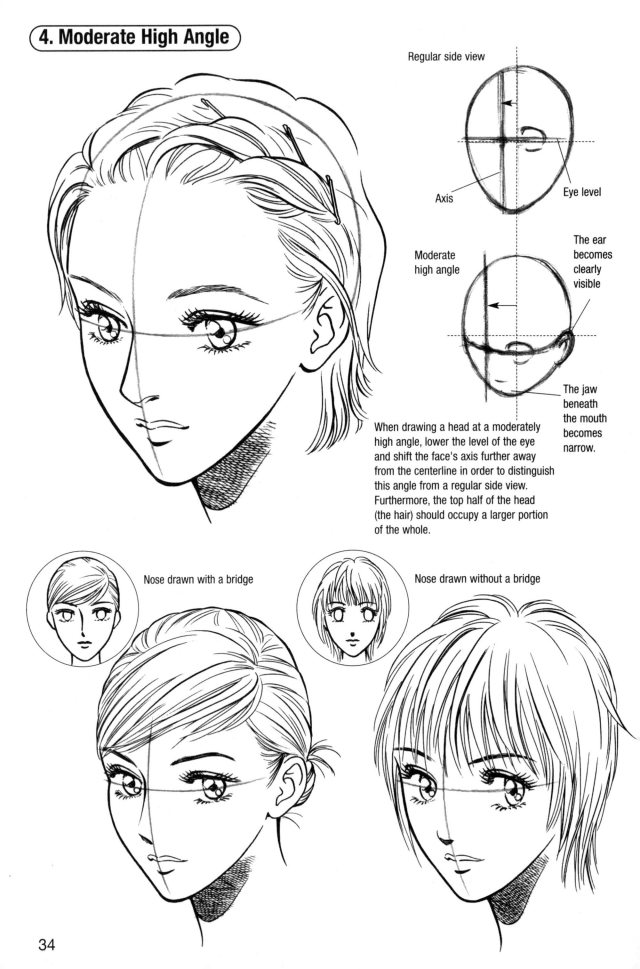

Regular side view

Axis

Eye level

Moderate high angle

The ear becomes clearly visible

The jaw beneath the mouth becomes narrow.

When drawing a head at a moderately high angle, lower the level of the eye and shift the face's axis further away from the centerline in order to distinguish this angle from a regular side view. Furthermore, the top half of the head (the hair) should occupy a larger portion of the whole.

Nose drawn with a bridge

Nose drawn without a bridge

Connecting the Neck and the Torso

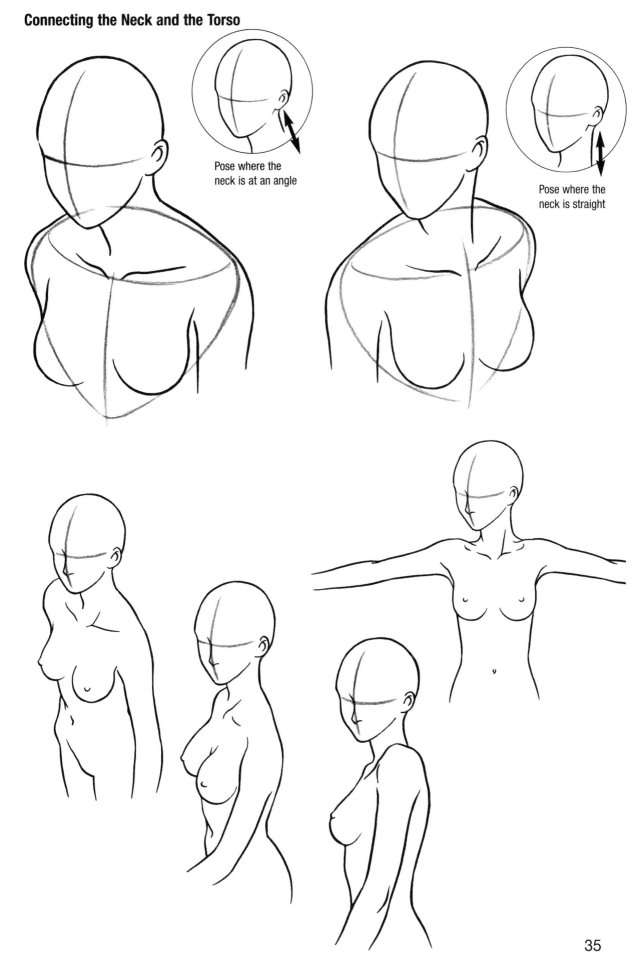

Pose where the
neck is at an angle

Pose where the
neck is straight

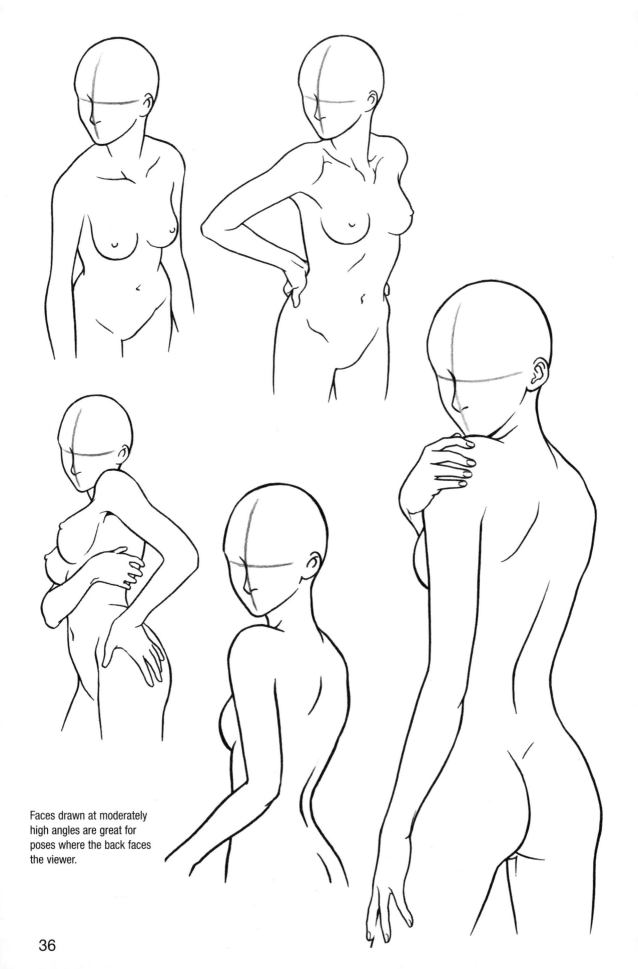

Faces drawn at moderately
high angles are great for
poses where the back faces
the viewer.

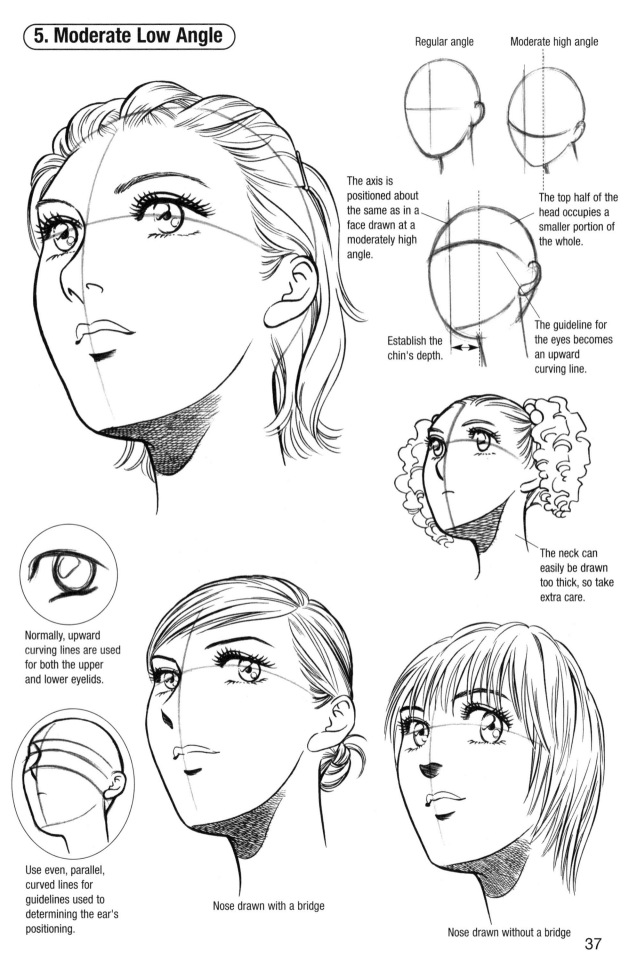

Regular angle

Moderate high angle

The axis is positioned about the same as in a face drawn at a moderately high angle.

The top half of the head occupies a smaller portion of the whole.

Establish the chin's depth.

The guideline for the eyes becomes an upward curving line.

The neck can easily be drawn too thick, so take extra care.

Normally, upward curving lines are used for both the upper and lower eyelids.

Use even, parallel, curved lines for guidelines used to determining the ear's positioning.

Nose drawn with a bridge

Nose drawn without a bridge

Connecting the Neck and the Torso

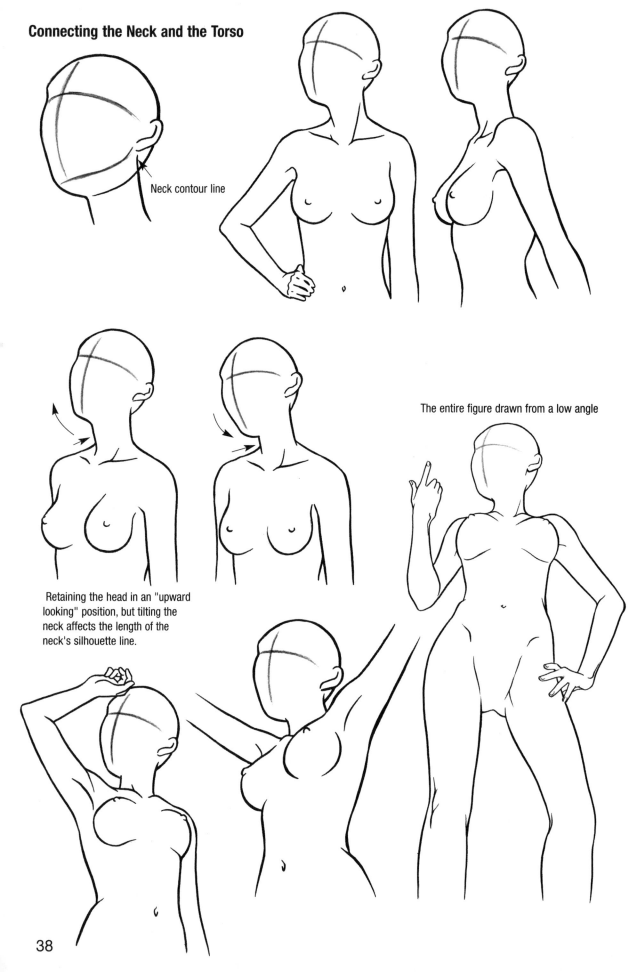

Neck contour line

The entire figure drawn from a low angle

Retaining the head in an "upward looking" position, but tilting the neck affects the length of the neck's silhouette line.

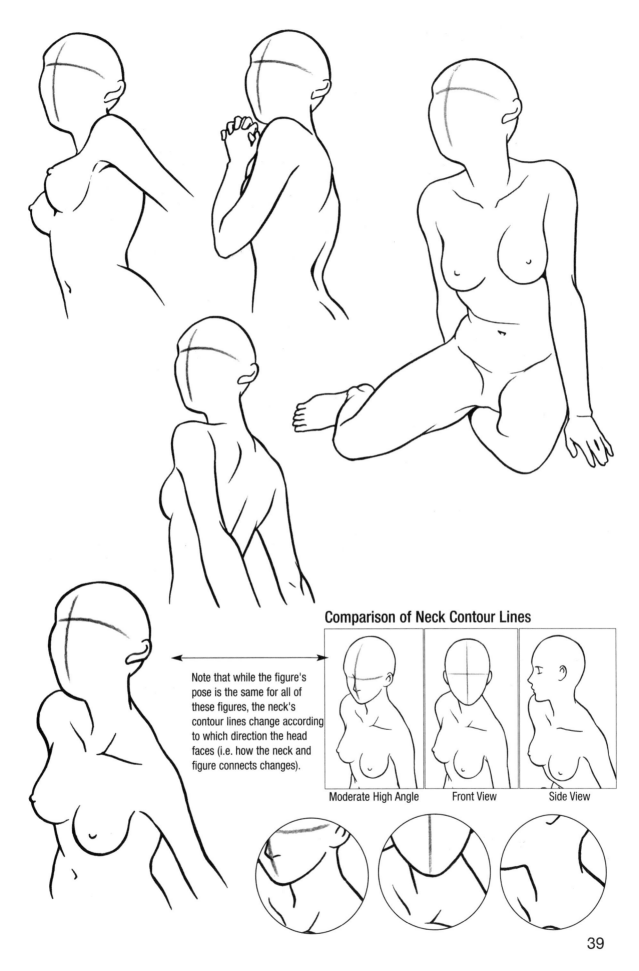

Comparison of Neck Contour Lines

Note that while the figure's pose is the same for all of these figures, the neck's contour lines change according to which direction the head faces (i.e. how the neck and figure connects changes).

Moderate High Angle

Front View

Side View

Changes in Eye Shape for Each of the 5 Views

Front View **Side View**

Standard Eyes

Upward Tilted Eyes

Downward Tilted Eyes

Large, Round Eyes

Narrow Eyes

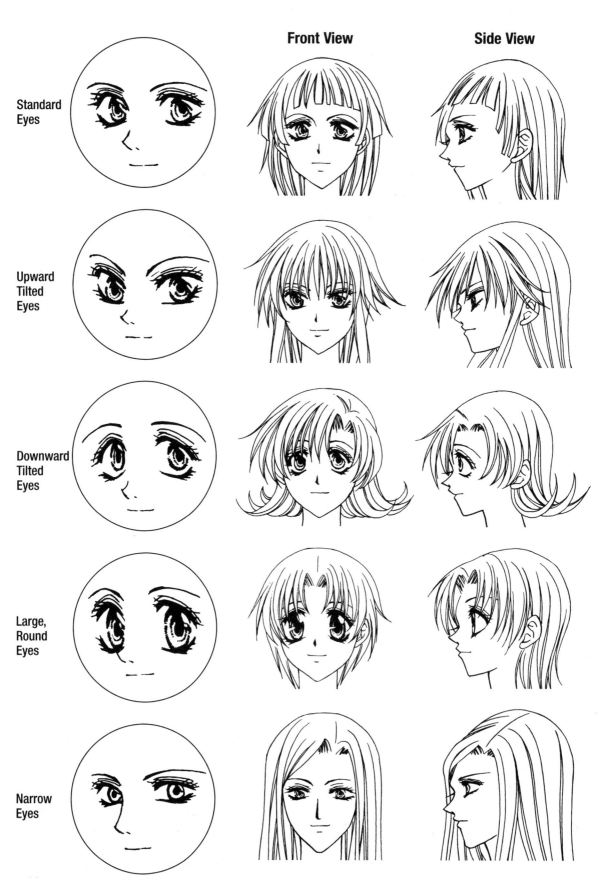

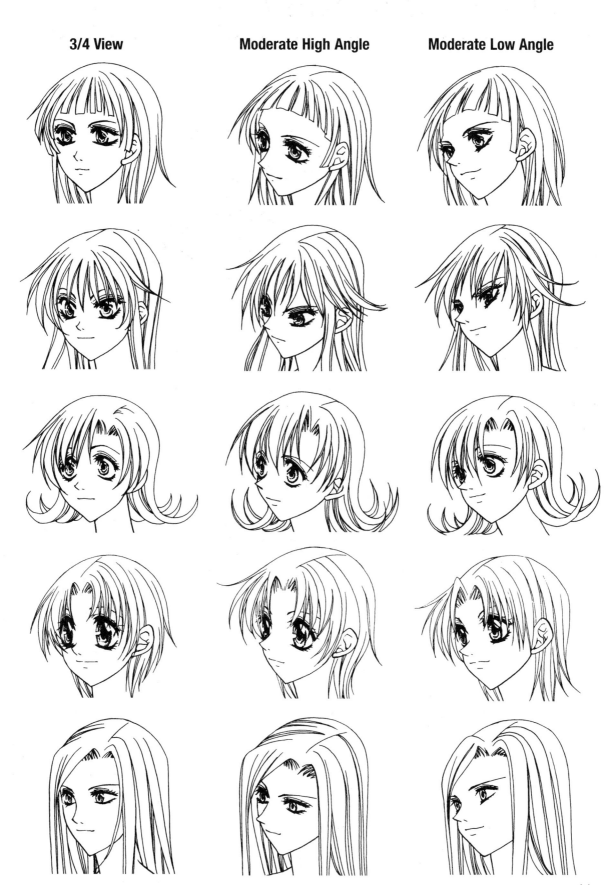

3/4 View **Moderate High Angle** **Moderate Low Angle**

Back of the Head

Depictions of characters from behind are essential in *manga*. If you are able to draw characters' heads from behind, the possibilities for dialogue scenes will expand dramatically.

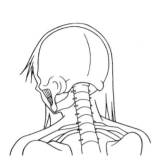

Skeletal drawing of the back of the head

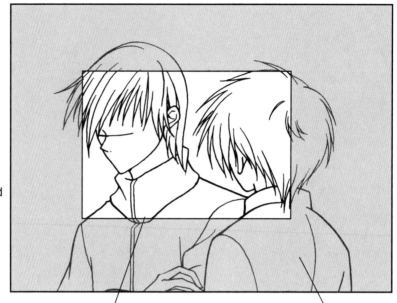

Sample Close-ups

Given the variety in panel shapes and margin sizes, the possibilities compositions are endless.

If you can draw this area successfully, you can create a dialogue scene.

Target area to include in a panel, trimmed as needed

Assorted Scenes of Characters Face-to-Face

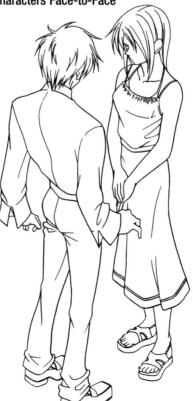

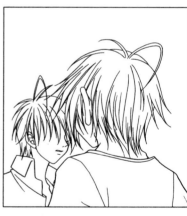

42

Key Features in Drawing the Back of the Head: The Ear and Hair Flow

When the Ear Is Visible

Front View (Ref. Fig.)

When the ear and chin are visible:
- there is less hair in the bangs and sideburns, and the hair is short.
- Draw the head so that the shape of the back is clearly discernible.

When the Ear Is Not Visible

Front View (Ref. Fig.)

When the hair has little volume:
- the ears are not visible, and although the hair is long, since it has little volume, it should hang closely to the head.
- The head should have a round slope from the top of the head to the back.

When the bangs have plenty of volume: Show the bangs clearly fluffing outward. Ensure that you do not give the back of the head too much hair.

Front View (Ref. Fig.)

Front View (Ref. Fig.)

With voluminous hair:
- Use the hair's silhouette lines and flow to suggest clearly that it is in fact the back of the head.

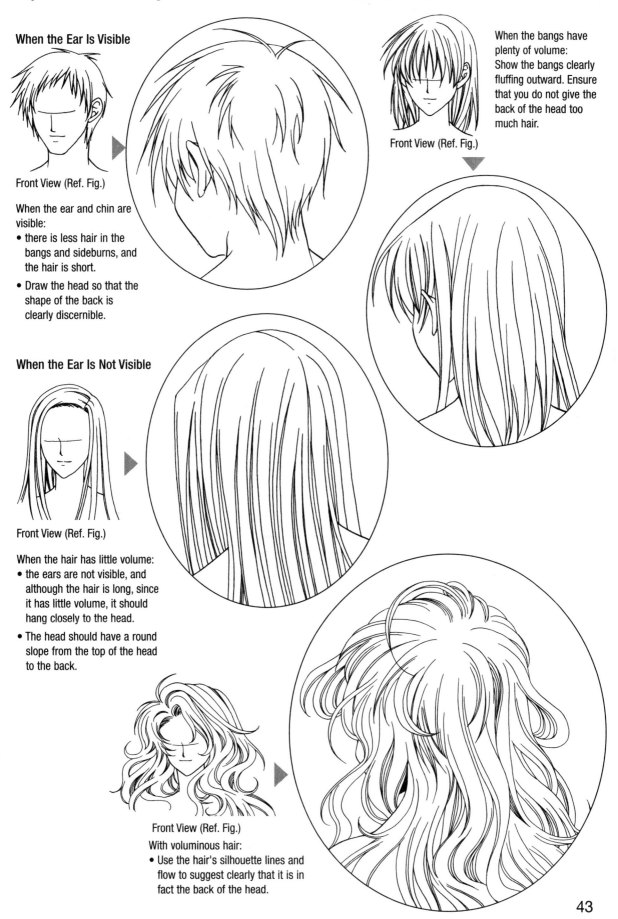

The Eyes are the Face's Key Feature.

Maintaining Variety in the Characters' Eyes

These 3 beauties all have completely different eyes. Design the eyes so that the particular character can be recognized even in a close-up of just the eyes.

Good
• • • • • ▶

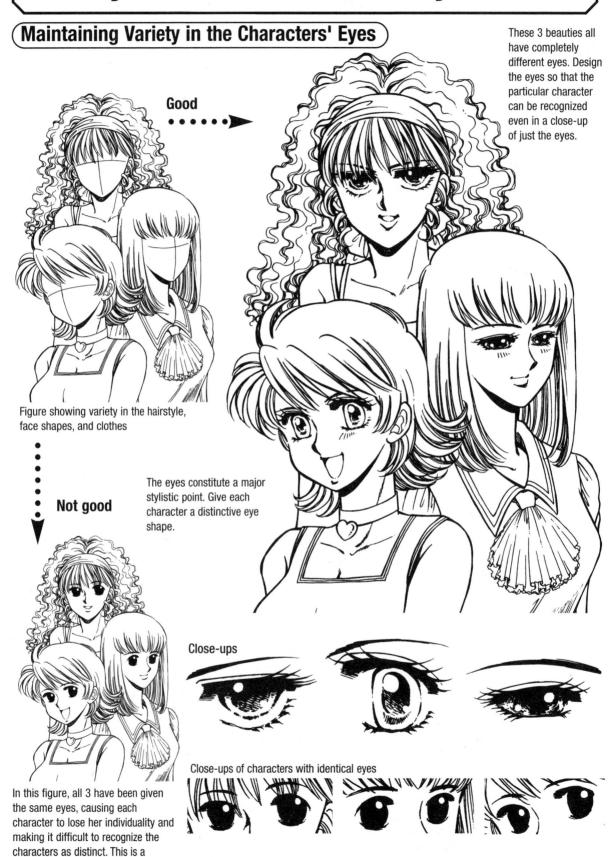

Figure showing variety in the hairstyle, face shapes, and clothes

•
•
•
•
•

Not good
▼

The eyes constitute a major stylistic point. Give each character a distinctive eye shape.

Close-ups

Close-ups of characters with identical eyes

In this figure, all 3 have been given the same eyes, causing each character to lose her individuality and making it difficult to recognize the characters as distinct. This is a common pitfall for beginning artists.

Inking Process

• Hatching: Process for Rendering Eyes Using Primarily Hatching

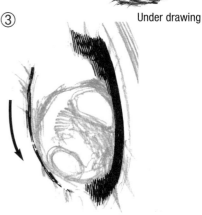

Under drawing

①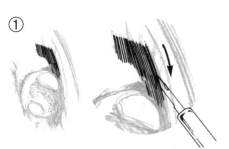

1. Start with the upper eyelid. Draw gentle curves while rotating the paper in the direction easiest to draw.

②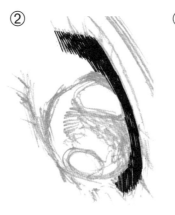

2. Draw the upper eyelid. Build up strokes, keeping them at a comfortable, not overly long length.

③

3. Draw the lower eyelid. Since you are using hatching to render the eye, make sure that the fine contour of the lower eyelid does not evolve into a single (solid) line. Use fine, connecting strokes.

④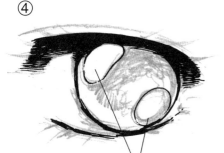

4. Draw the outlines of the iris and the light reflections. Take care to avoid allowing the iris outline from becoming a solid line.

Since these are light reflections, use as fine a solid line as possible.

⑤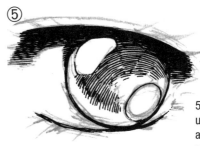

5. For the hatching inside the iris, use curved lines, maintaining an awareness of the iris's curved surface.

⑥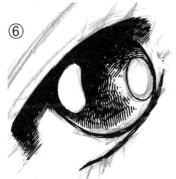

6. Use hatching to finish off the iris and pupil. Build up light and shadow, rotating the paper in the direction easiest to draw.

⑦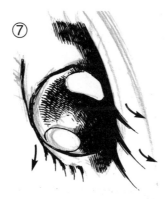

7. To finish the eyelashes, the key is to draw shorter lines clustered around a long, central line. Take care to use beautiful, tapered lines.

⑧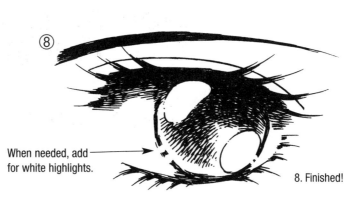

When needed, add for white highlights.

8. Finished!

45

• Using Contour Lines: Process for Rendering Eyes Using Primarily Contour Lines

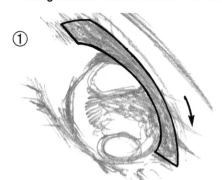

①

1. Draw the contour of the upper eyelid. (The paper often must be rotated to the direction easiest to draw.)

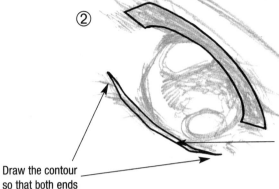

②

Draw the contour so that both ends come to distinct points

2. Draw the contour of the lower eyelid.

Take care to prevent the contour from becoming overly thick. (If the drawing is small, then you may simply use a solid line.)

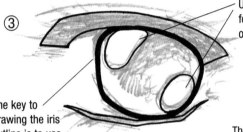

③

Use ultra fine lines for light reflection outlines.

The key to drawing the iris outline is to use a uniform, heavy line.

3. Draw the iris, pupil, and light reflections.

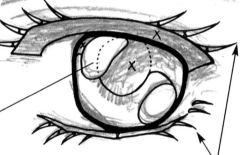

④

The inside of the dotted lines denotes the actual pupil.

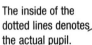

4. Draw the eyelashes and the inside of the iris. X indicates which areas are to be filled with solid black.

Ensure that each eyelash ends in a clear point.

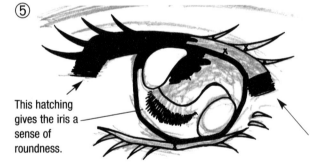

⑤

This hatching gives the iris a sense of roundness.

Add hatching at both corners of the eye. This creates the illusion that the upper and lower eyelids are connected.

5. Spotting Blacks and Hatching

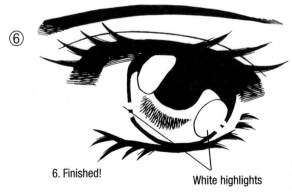

⑥

6. Finished!

White highlights

If the eyelashes are rendered solely in solid black and end up with a rough, crude feel, add fine, individual lines separated from the main lashes.

Distinguishing Different Eye Types

The following pages discuss 5 common eye types: standard eyes, upward tilted eyes, downward tilted eyes, large, round eyes, and almond-shaped eyes.

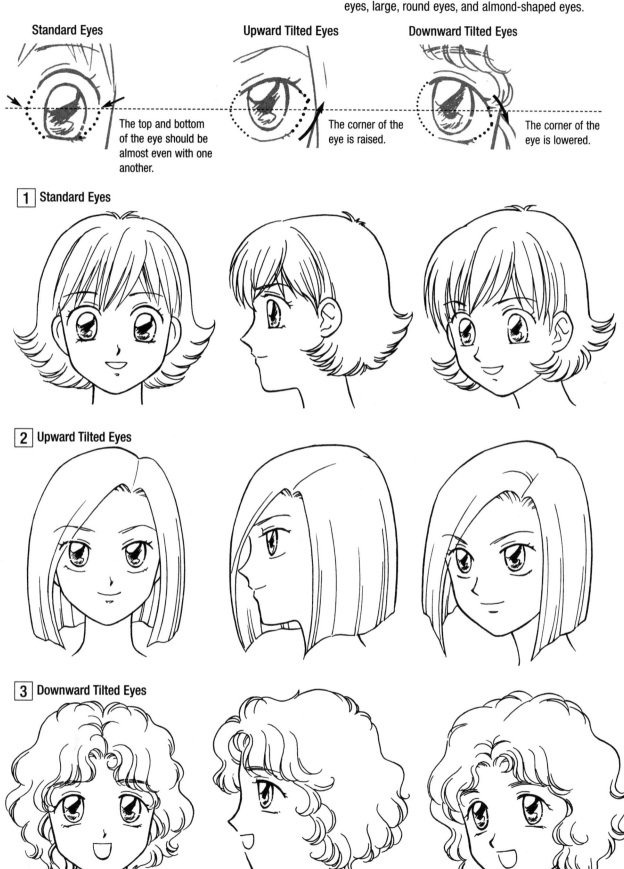

Standard Eyes

The top and bottom of the eye should be almost even with one another.

Upward Tilted Eyes

The corner of the eye is raised.

Downward Tilted Eyes

The corner of the eye is lowered.

1 Standard Eyes

2 Upward Tilted Eyes

3 Downward Tilted Eyes

4 Large, Round Eyes

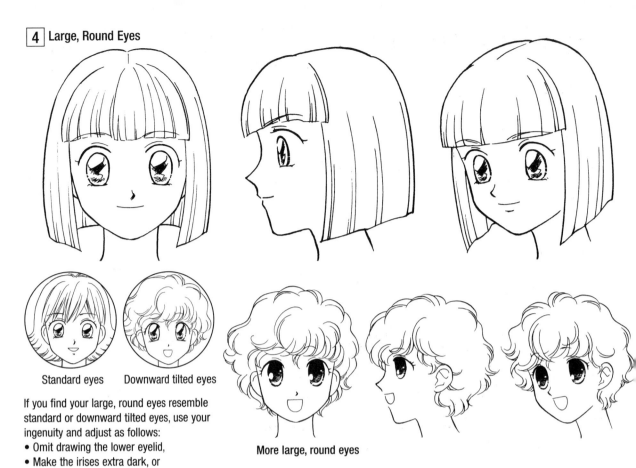

Standard eyes Downward tilted eyes

If you find your large, round eyes resemble standard or downward tilted eyes, use your ingenuity and adjust as follows:
• Omit drawing the lower eyelid,
• Make the irises extra dark, or adjust how you render the eye's interior, etc.

More large, round eyes

5 Almond-shaped Eyes

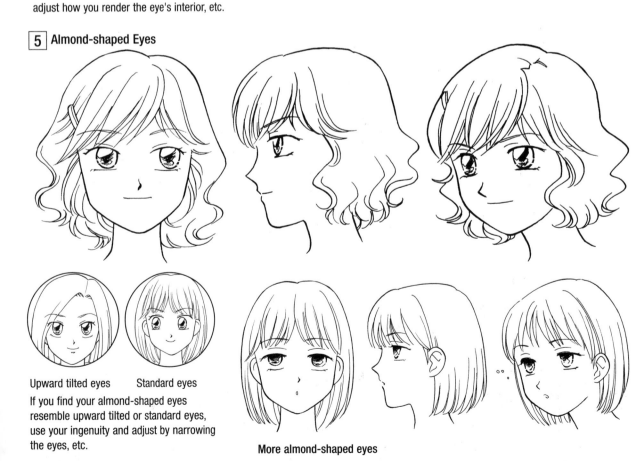

Upward tilted eyes Standard eyes

If you find your almond-shaped eyes resemble upward tilted or standard eyes, use your ingenuity and adjust by narrowing the eyes, etc.

More almond-shaped eyes

Distinguishing Ages

Making Children Look Childlike

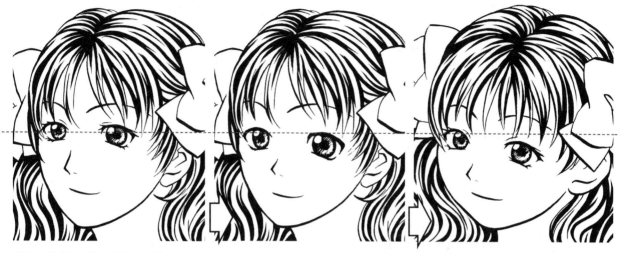

Older Child with a Mature Face

Somewhat Mature Child

This face basically has the same shape contour as that of the mature face, but the features have been altered.
- The eyelashes were omitted.
- The eyes were enlarged.
- The bridge of the nose was reduced.

Child

Here, the face's contour is different and the facial features' proportions have been adjusted.
- The cheeks were made fuller.
- The eyes' position was lowered.
- The eyes were spaced farther apart.
- The portion taken up by the upper part of the head was enlarged.

Adult's face Child's face

Eye Eye Eye Eye

To draw a child's face, concentrate all of the facial features toward the lower half of the face.

Not good

The presence of eyelashes and small eyes tend to detract from a childlike appearance.

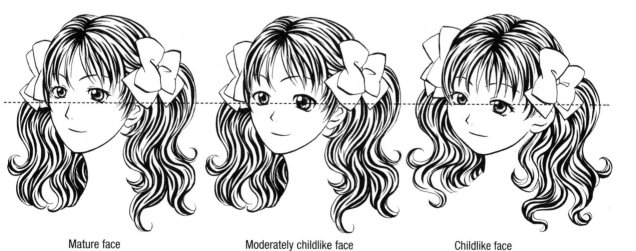

Mature face

Moderately childlike face

Childlike face

49

Differences between Adult and Child Faces

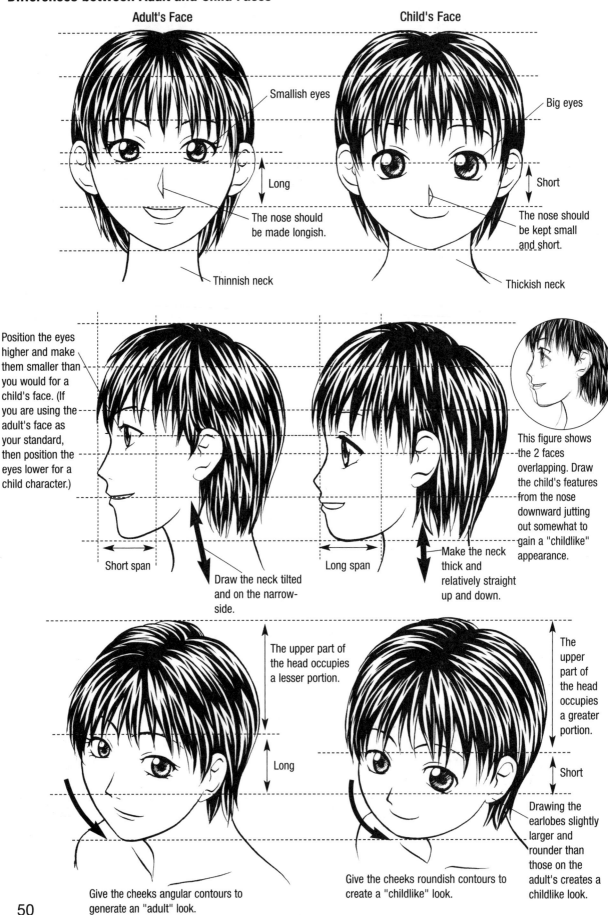

Adult's Face

Smallish eyes

Long

The nose should be made longish.

Thinnish neck

Child's Face

Big eyes

Short

The nose should be kept small and short.

Thickish neck

Position the eyes higher and make them smaller than you would for a child's face. (If you are using the adult's face as your standard, then position the eyes lower for a child character.)

Short span

Draw the neck tilted and on the narrow-side.

Long span

Make the neck thick and relatively straight up and down.

This figure shows the 2 faces overlapping. Draw the child's features from the nose downward jutting out somewhat to gain a "childlike" appearance.

The upper part of the head occupies a lesser portion.

Long

Give the cheeks angular contours to generate an "adult" look.

The upper part of the head occupies a greater portion.

Short

Drawing the earlobes slightly larger and rounder than those on the adult's creates a childlike look.

Give the cheeks roundish contours to create a "childlike" look.

Distinguishing Youthful and Elderly Faces

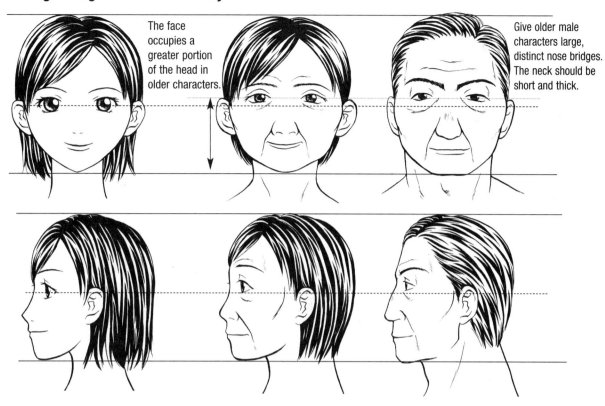

The face occupies a greater portion of the head in older characters.

Give older male characters large, distinct nose bridges. The neck should be short and thick.

Pointers in Aging Characters

- Reduce the size of the eyes and irises.
- Omit the eyelashes.
- Give the hair less volume.

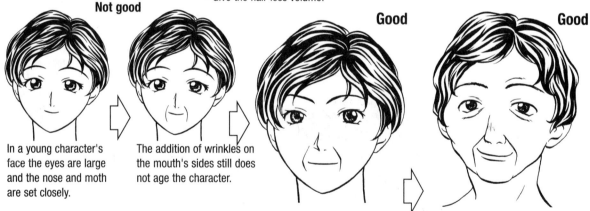

Not good

Good

Good

In a young character's face the eyes are large and the nose and moth are set closely.

The addition of wrinkles on the mouth's sides still does not age the character.

Pitfalls: Wrinkles alone do not make an old person.

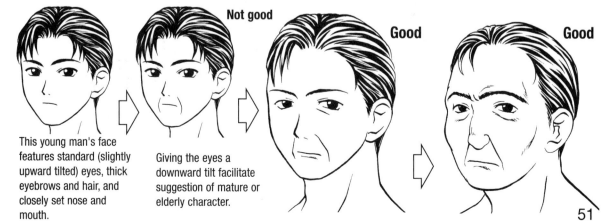

Not good

Good

Good

This young man's face features standard (slightly upward tilted) eyes, thick eyebrows and hair, and closely set nose and mouth.

Giving the eyes a downward tilt facilitate suggestion of mature or elderly character.

51

Male vs. Female Faces

Male and female characters share virtually the same eye, nose, mouth, and ear positioning.

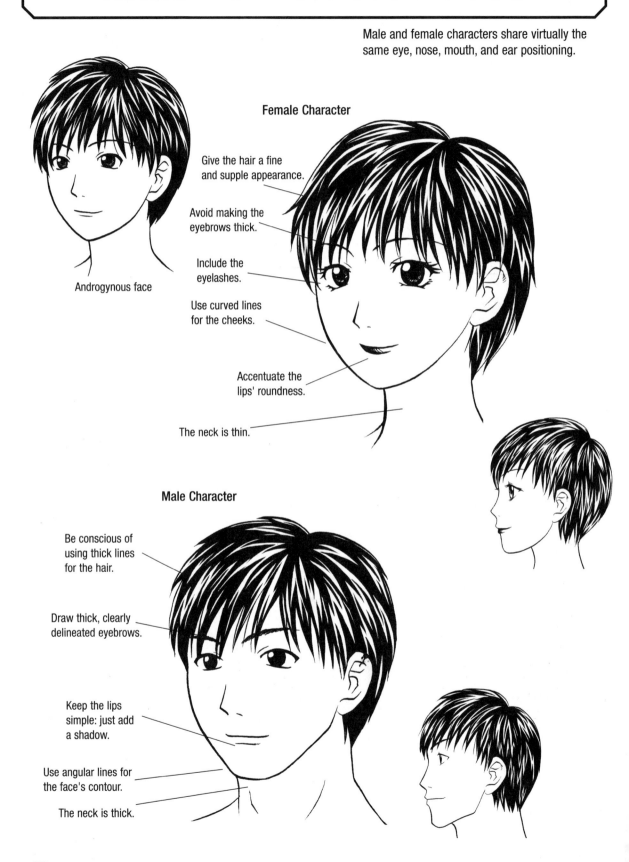

Female Character

Give the hair a fine and supple appearance.

Avoid making the eyebrows thick.

Include the eyelashes.

Use curved lines for the cheeks.

Accentuate the lips' roundness.

The neck is thin.

Androgynous face

Male Character

Be conscious of using thick lines for the hair.

Draw thick, clearly delineated eyebrows.

Keep the lips simple: just add a shadow.

Use angular lines for the face's contour.

The neck is thick.

Giving a Character That Feminine Touch

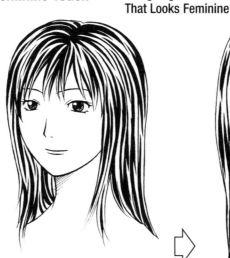

Designing a Character That Looks Feminine

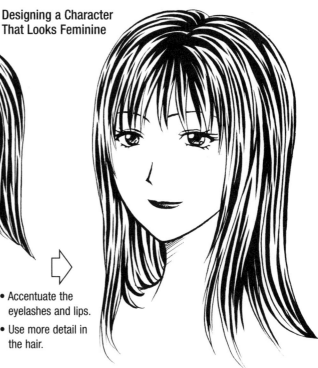

- Enlarge the eyes.
- Darken the eyelashes.
- Move the neck contour inward, and draw the neck long and thin.

- Accentuate the eyelashes and lips.
- Use more detail in the hair.

Making a Guy Look Like More a Guy

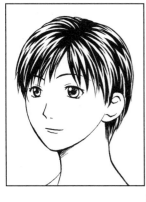

Designing a Character That Looks Masculine

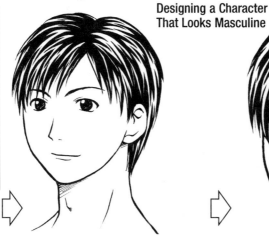

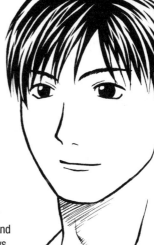

- Reduce the size of the irises.
- Make the neck thicker.

- Use a heavy line for the face's contour and thicken the eyebrows.
- Accentuate the bridge of the nose.

The Face Contour

A female character's facial contour can also be applied to a male character's face.

Angular, bony facial contours are not usually used with female faces.

Male Face Types

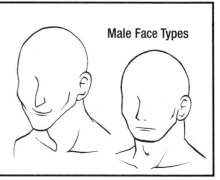

53

Pointers in Drawing Cute Female Characters

1. Enlarge the eyes. **Good**

Not good

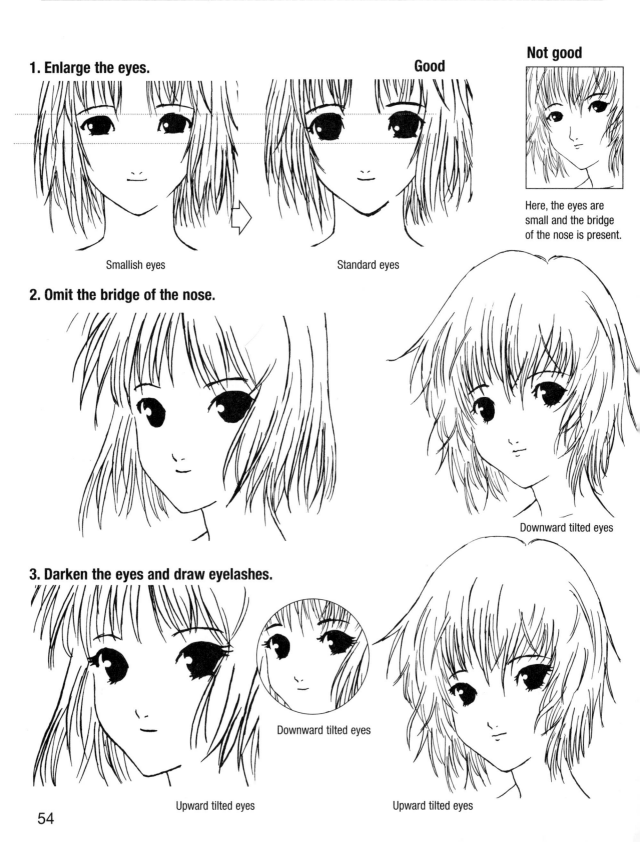

Here, the eyes are small and the bridge of the nose is present.

Smallish eyes Standard eyes

2. Omit the bridge of the nose.

Downward tilted eyes

3. Darken the eyes and draw eyelashes.

Downward tilted eyes

Upward tilted eyes Upward tilted eyes

54

Cute Accessories and Hairstyles

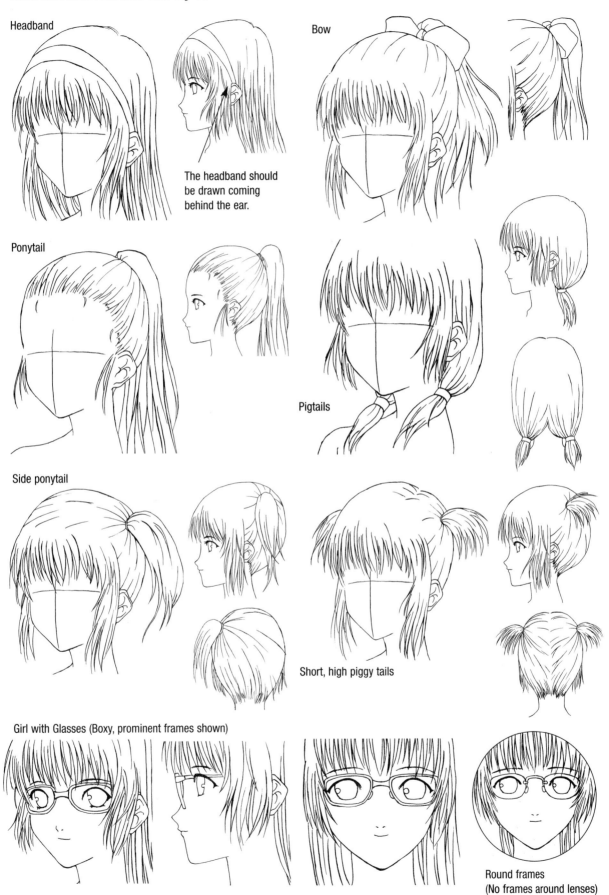

Headband

The headband should be drawn coming behind the ear.

Bow

Ponytail

Pigtails

Side ponytail

Short, high piggy tails

Girl with Glasses (Boxy, prominent frames shown)

Round frames
(No frames around lenses)

55

Creating Adult Faces

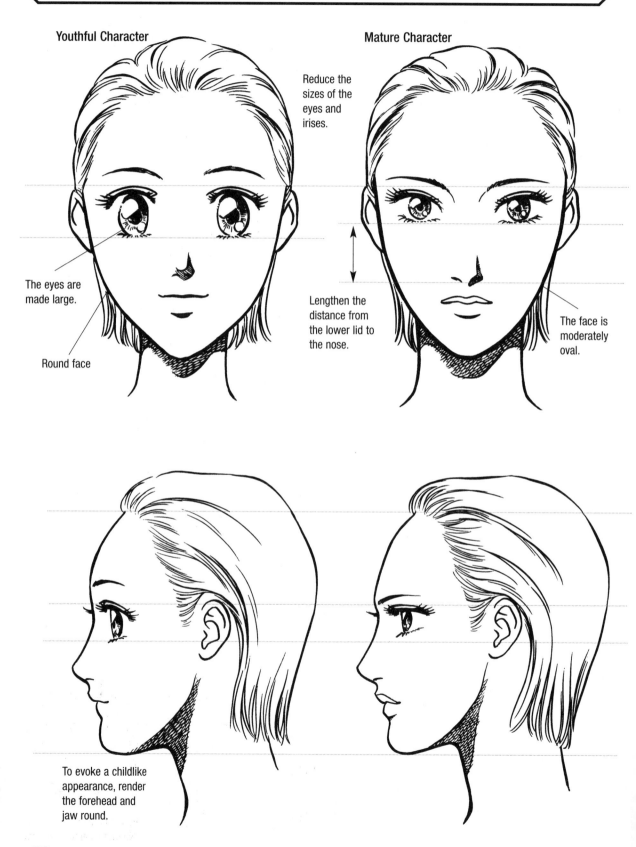

Youthful Character

Mature Character

Reduce the sizes of the eyes and irises.

The eyes are made large.

Round face

Lengthen the distance from the lower lid to the nose.

The face is moderately oval.

To evoke a childlike appearance, render the forehead and jaw round.

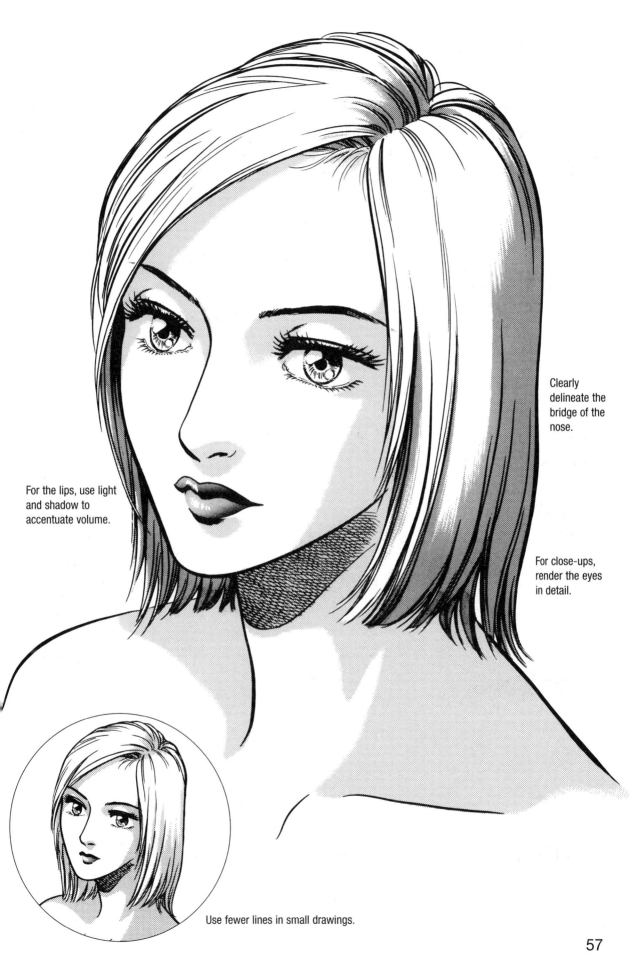

Clearly
delineate the
bridge of the
nose.

For the lips, use light
and shadow to
accentuate volume.

For close-ups,
render the eyes
in detail.

Use fewer lines in small drawings.

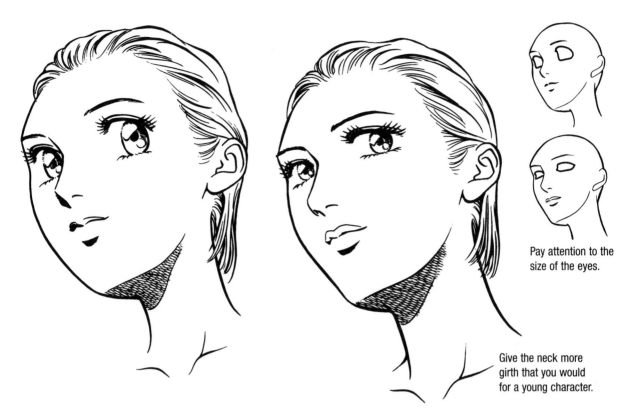

Pay attention to the size of the eyes.

Give the neck more girth that you would for a young character.

Rendering the Closing of the Eye and Depicting Eyelashes

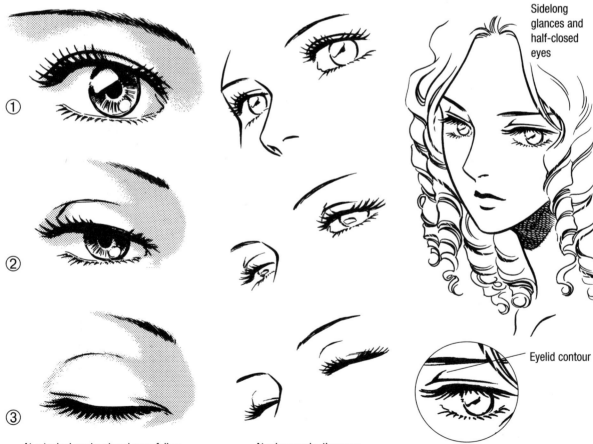

Sidelong glances and half-closed eyes

Eyelid contour

①

②

③

At a typical angle, closed eyes follow a downward curve.

At a low angle, the eyes take on an upward curve.

Use the same downward curve for the eyelashes of the upper eyelid that you would for a closed eye.

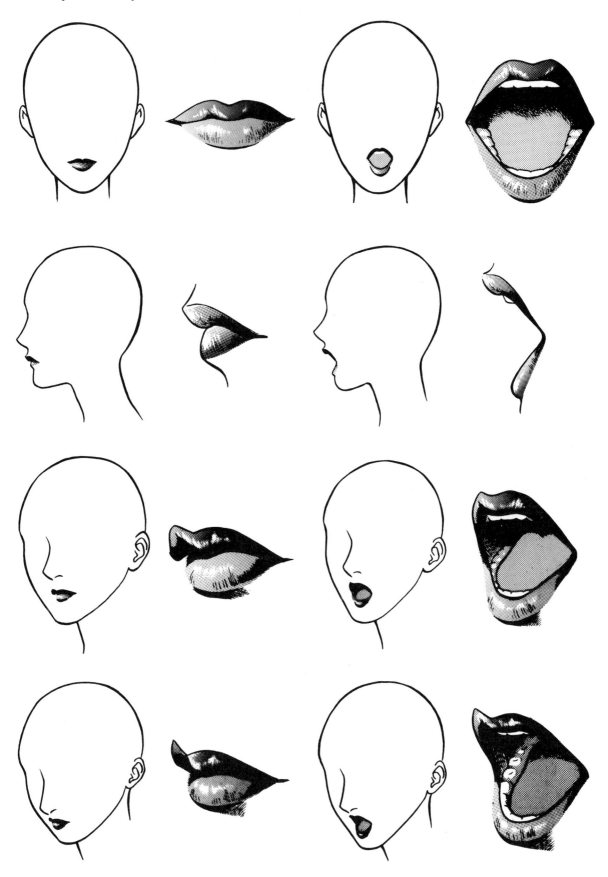

The Basics of the Human Figure

Making Effective Use of Even and Tapered Lines

The Male Form

Accentuating the muscular nature will allow you to suggest the hardness of the male body, so use even lines at the beginning of shoulder blade and hip bone contours.

Draw a downward, tapered line cutting ever so slightly inward. This subtle touch will accentuate the figure's muscular look, generating a sense of manliness. In contrast, use smooth, unbroken lines for a female figure's contours.

Here we see a waist-to-hip contour used for a female figure.

Use a tapered line for the point where the shoulder joins the neck, since it also marks the swell of the muscle.

The bony shape of the elbow is discernible. Use both even and tapered lines when drawing a male character in order to achieve a rugged, craggy appearance.

While the suit jacket is roomy, undulations form owing to protrusions and recesses in the body, such as the shoulder blade, waist, and elbows.

Bunching formed by the loose trouser fabric.

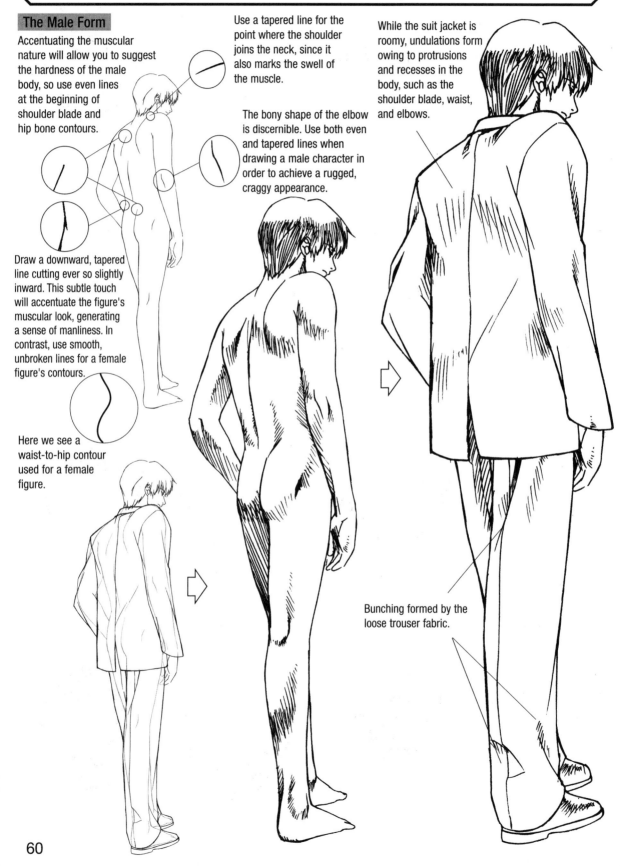

60

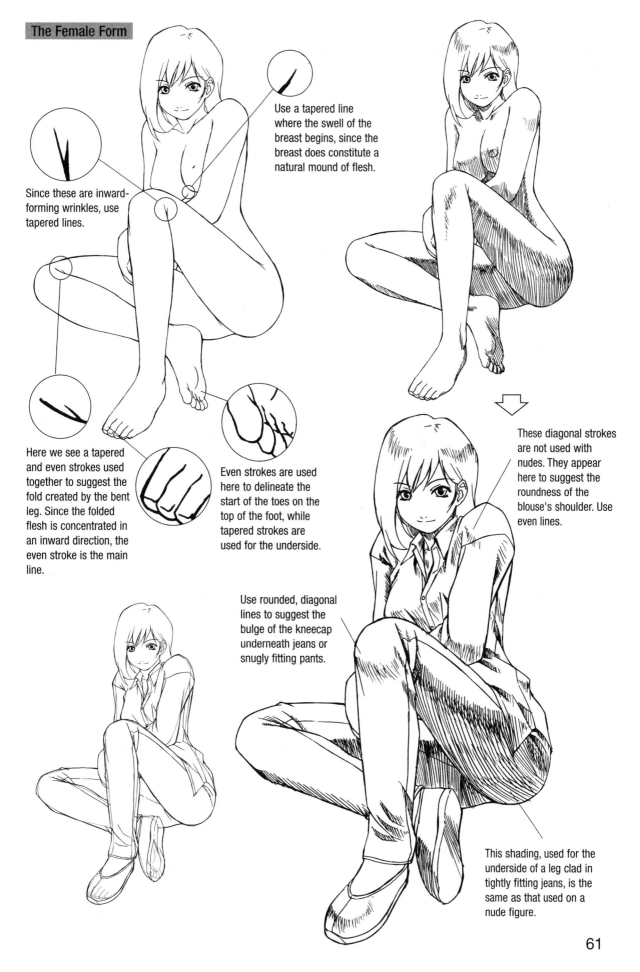

Since these are inward-forming wrinkles, use tapered lines.

Use a tapered line where the swell of the breast begins, since the breast does constitute a natural mound of flesh.

Here we see a tapered and even strokes used together to suggest the fold created by the bent leg. Since the folded flesh is concentrated in an inward direction, the even stroke is the main line.

Even strokes are used here to delineate the start of the toes on the top of the foot, while tapered strokes are used for the underside.

These diagonal strokes are not used with nudes. They appear here to suggest the roundness of the blouse's shoulder. Use even lines.

Use rounded, diagonal lines to suggest the bulge of the kneecap underneath jeans or snugly fitting pants.

This shading, used for the underside of a leg clad in tightly fitting jeans, is the same as that used on a nude figure.

61

Inking the Figure: Using the Different Lines Appropriately

Making the line heavier in strategic locations will generate a sense of volume and presence.

Pointers in Thickening (Darkening) Lines

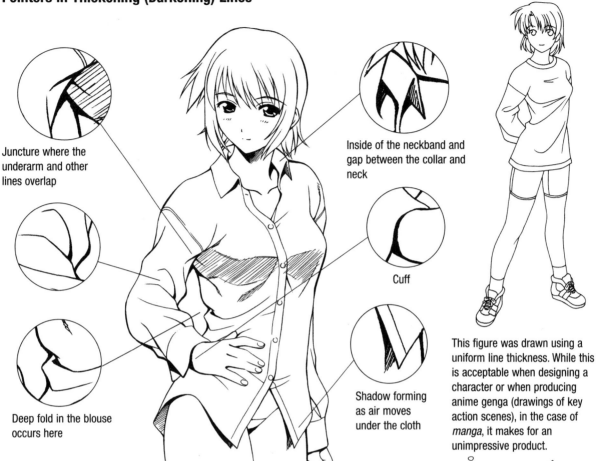

Juncture where the underarm and other lines overlap

Inside of the neckband and gap between the collar and neck

Cuff

Deep fold in the blouse occurs here

Shadow forming as air moves under the cloth

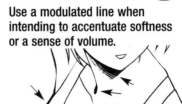

This figure was drawn using a uniform line thickness. While this is acceptable when designing a character or when producing anime genga (drawings of key action scenes), in the case of *manga*, it makes for an unimpressive product.

Line Modulation

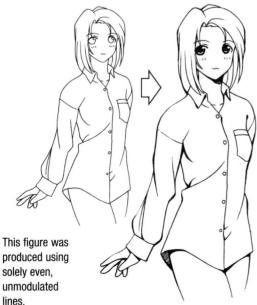

This figure was produced using solely even, unmodulated lines.

Here, portions of lines have been modulated by building them up using a dip or technical pen.

When emphasizing form, use an even line.

Use a modulated line when intending to accentuate softness or a sense of volume.

62

In high and low angles, use heavier lines for objects close to the picture plane.

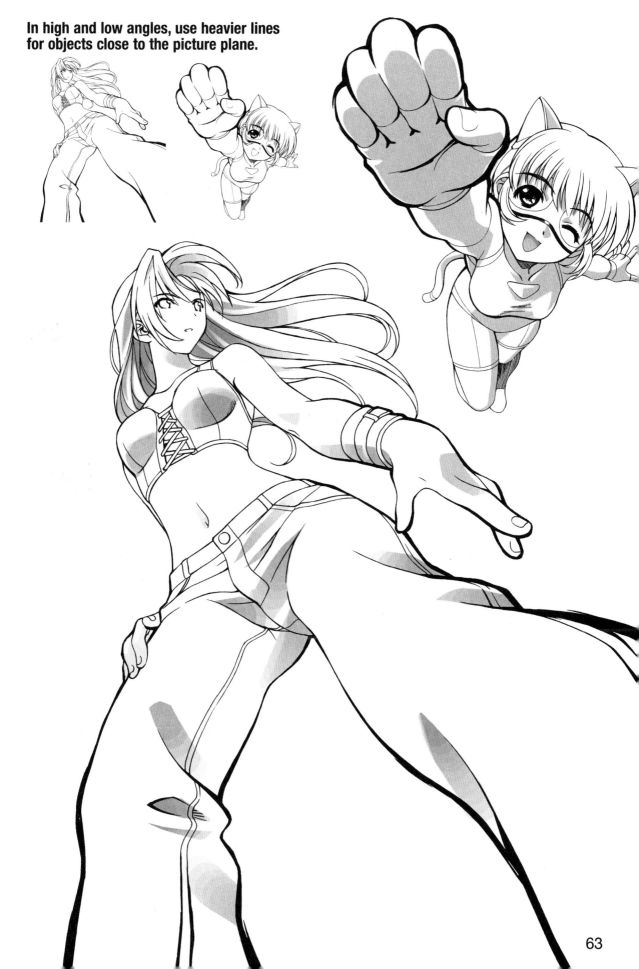

Creating a Sense of Volume: Shading

Light Source

When emphasizing a sense of volume or presence, determine the location of the light source and ink.

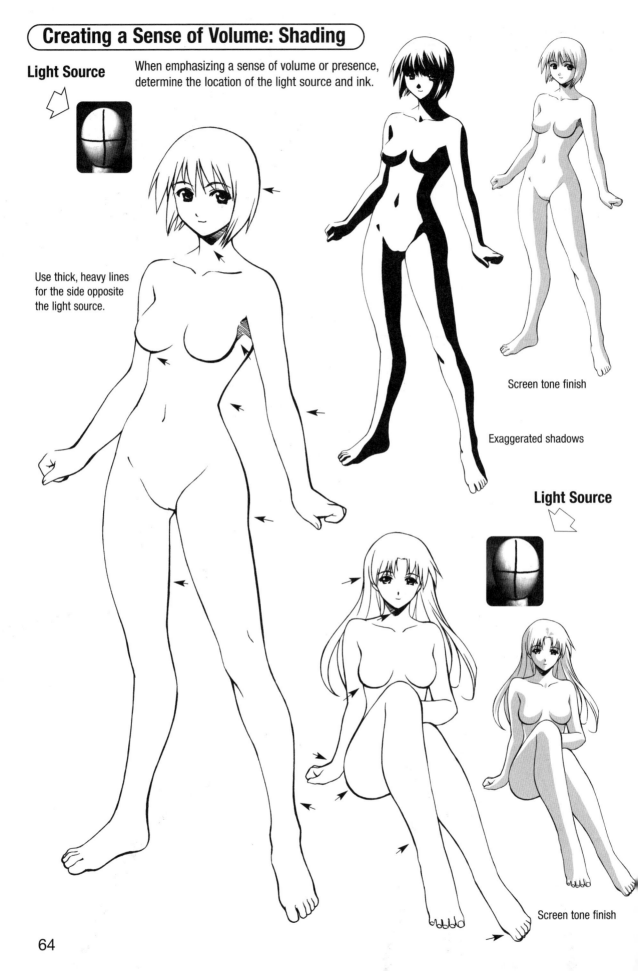

Use thick, heavy lines for the side opposite the light source.

Screen tone finish

Exaggerated shadows

Light Source

Screen tone finish

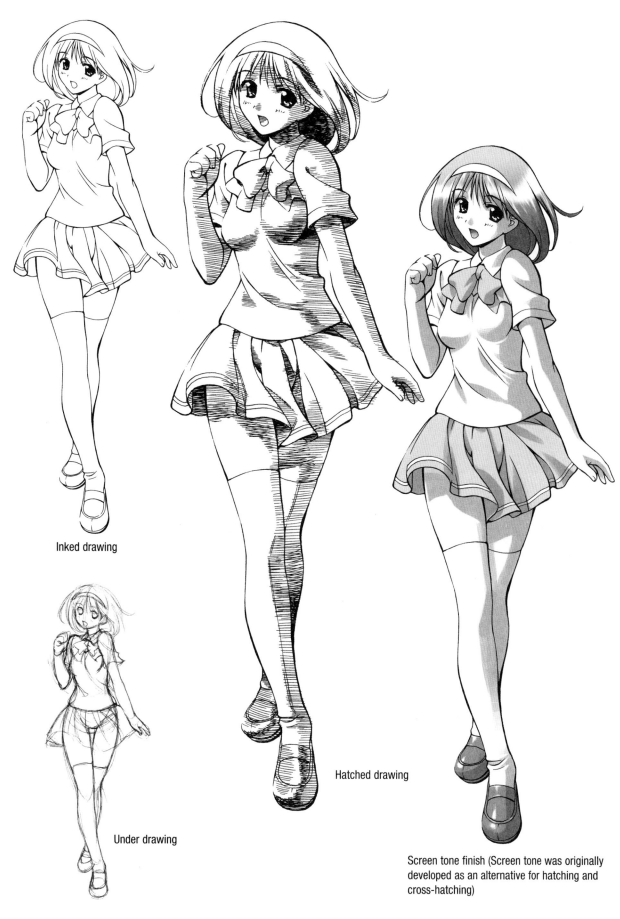

Inked drawing

Hatched drawing

Under drawing

Screen tone finish (Screen tone was originally developed as an alternative for hatching and cross-hatching)

Practical Application: Achieving a Sense of Volume Using Hatching, Etc.

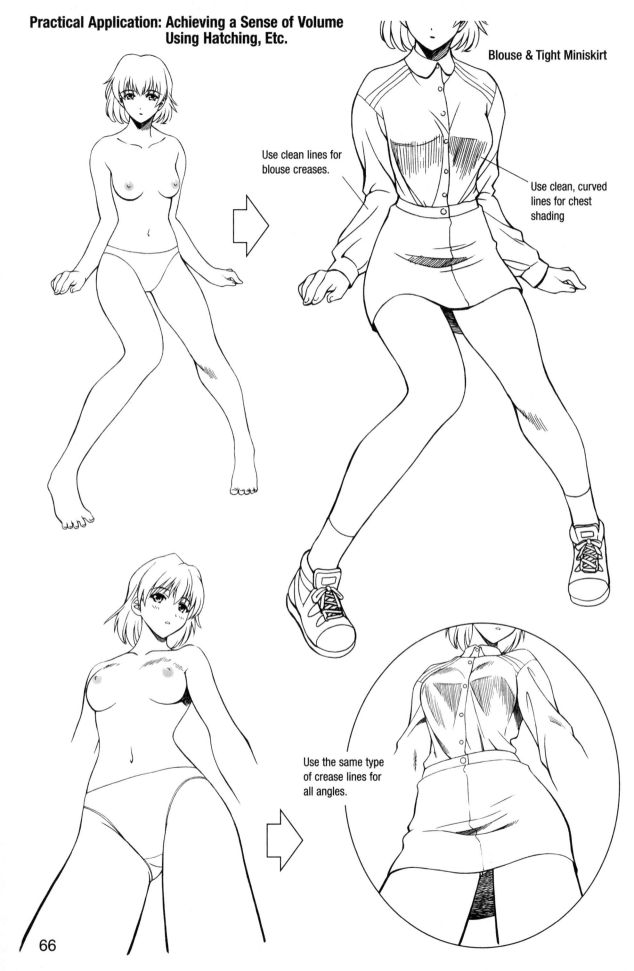

Blouse & Tight Miniskirt

Use clean lines for blouse creases.

Use clean, curved lines for chest shading

Use the same type of crease lines for all angles.

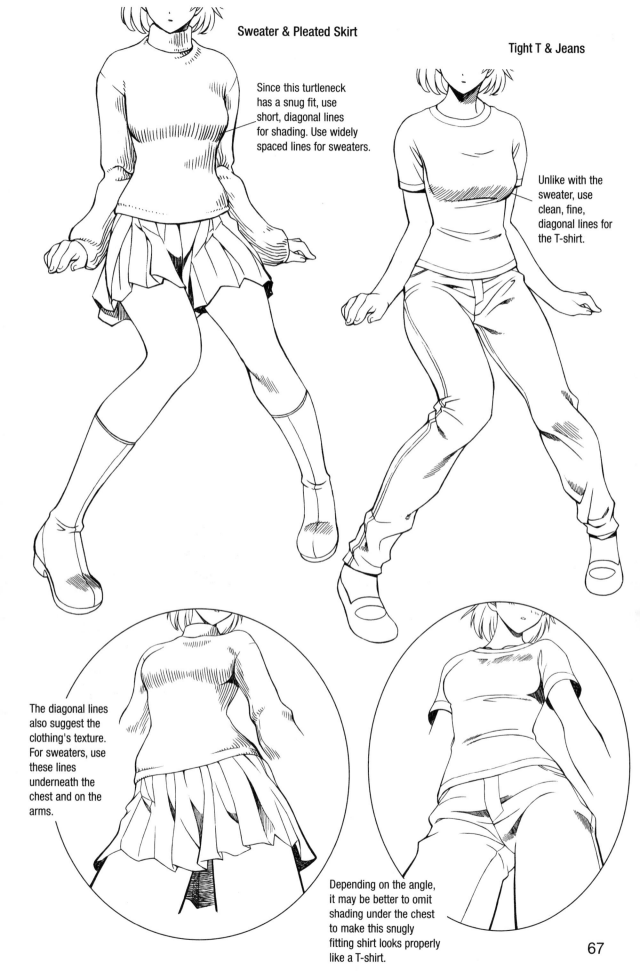

Sweater & Pleated Skirt

Tight T & Jeans

Since this turtleneck has a snug fit, use short, diagonal lines for shading. Use widely spaced lines for sweaters.

Unlike with the sweater, use clean, fine, diagonal lines for the T-shirt.

The diagonal lines also suggest the clothing's texture. For sweaters, use these lines underneath the chest and on the arms.

Depending on the angle, it may be better to omit shading under the chest to make this snugly fitting shirt looks properly like a T-shirt.

67

Drawing the Back

The shoulder blade and waist are the main body parts affecting crease formation in clothing. Add creases and diagonal strokes for shading focused primarily on the right or left shoulder blade, depending on the direction that the figure faces.

Blouse

Sweater

Use broad shadows. Emphasize them.

T-Shirt

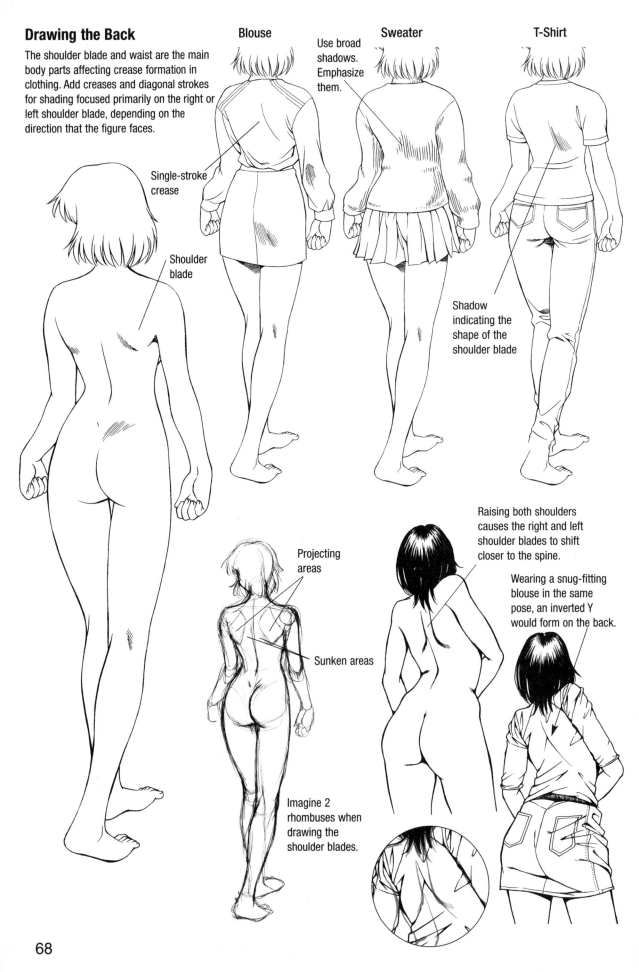

Single-stroke crease

Shoulder blade

Shadow indicating the shape of the shoulder blade

Projecting areas

Sunken areas

Imagine 2 rhombuses when drawing the shoulder blades.

Raising both shoulders causes the right and left shoulder blades to shift closer to the spine.

Wearing a snug-fitting blouse in the same pose, an inverted Y would form on the back.

68

Using Lines to Reinforce Body Types

• Emphasizing Curves

Make extensive use of diagonal lines and solid blacks to underscore the contrast of the figure's hills and valleys.

These diagonal lines (shading) on and underneath the chest emphasize the swell of the breasts.

Use heavy lines to accentuate the chest, waist, and hips.

Lithe, elastic curves

Use a G-pen to build up lines.

• Drawing Slim Figures

Use as unmodulated lines as possible for the figure's contours.

Use a gently sloping curve from the hip to the thigh.

Use a kabura or maru-pen.

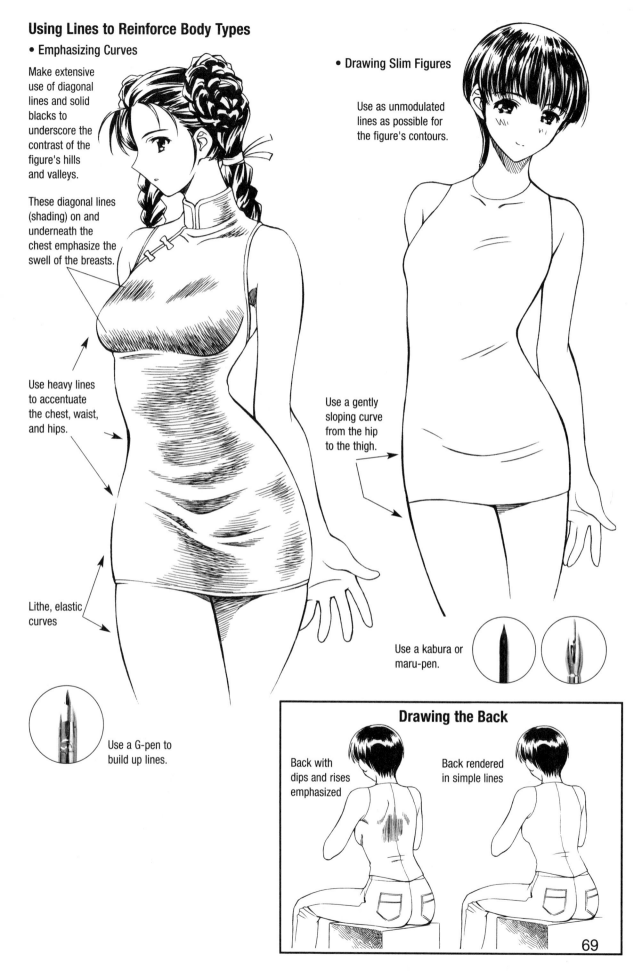

Drawing the Back

Back with dips and rises emphasized

Back rendered in simple lines

Distinguishing Female Body Types

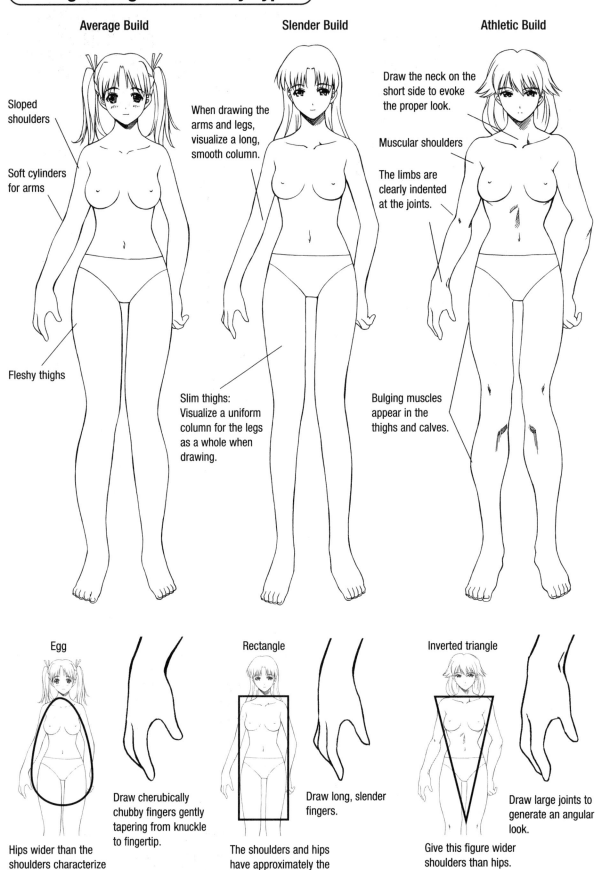

Average Build

Sloped shoulders

Soft cylinders for arms

Fleshy thighs

Slender Build

When drawing the arms and legs, visualize a long, smooth column.

Slim thighs: Visualize a uniform column for the legs as a whole when drawing.

Athletic Build

Draw the neck on the short side to evoke the proper look.

Muscular shoulders

The limbs are clearly indented at the joints.

Bulging muscles appear in the thighs and calves.

Egg

Hips wider than the shoulders characterize this body type.

Draw cherubically chubby fingers gently tapering from knuckle to fingertip.

Rectangle

The shoulders and hips have approximately the same width.

Draw long, slender fingers.

Inverted triangle

Give this figure wider shoulders than hips.

Draw large joints to generate an angular look.

70

Key Feature in the Side View: The Posterior

Take care with thickness of the arms and wrists and the shape of the calves.

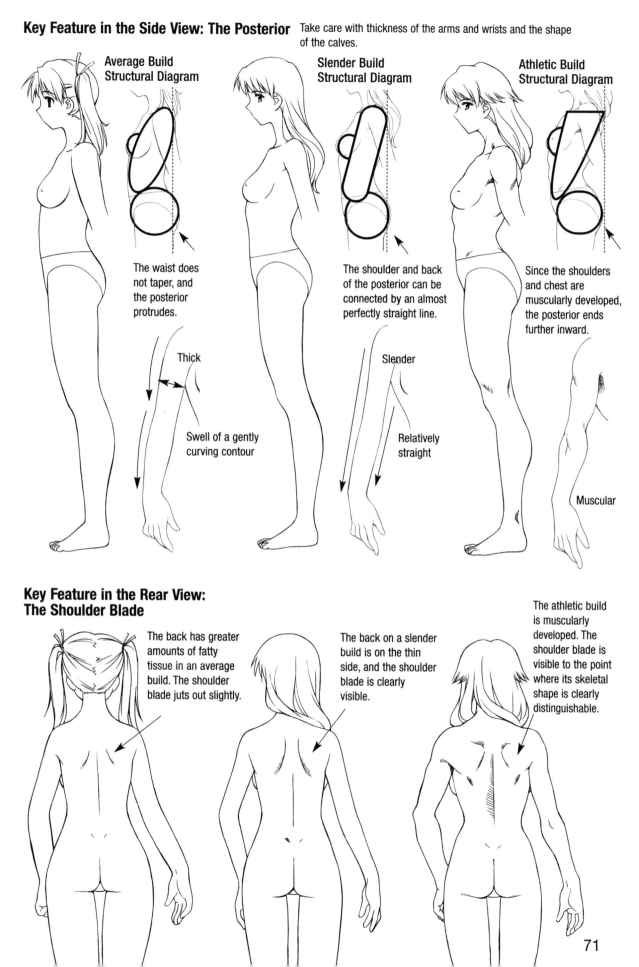

Average Build Structural Diagram

The waist does not taper, and the posterior protrudes.

Thick

Swell of a gently curving contour

Slender Build Structural Diagram

The shoulder and back of the posterior can be connected by an almost perfectly straight line.

Slender

Relatively straight

Athletic Build Structural Diagram

Since the shoulders and chest are muscularly developed, the posterior ends further inward.

Muscular

Key Feature in the Rear View: The Shoulder Blade

The back has greater amounts of fatty tissue in an average build. The shoulder blade juts out slightly.

The back on a slender build is on the thin side, and the shoulder blade is clearly visible.

The athletic build is muscularly developed. The shoulder blade is visible to the point where its skeletal shape is clearly distinguishable.

71

Distinguishing Breast Sizes

Average Large Small

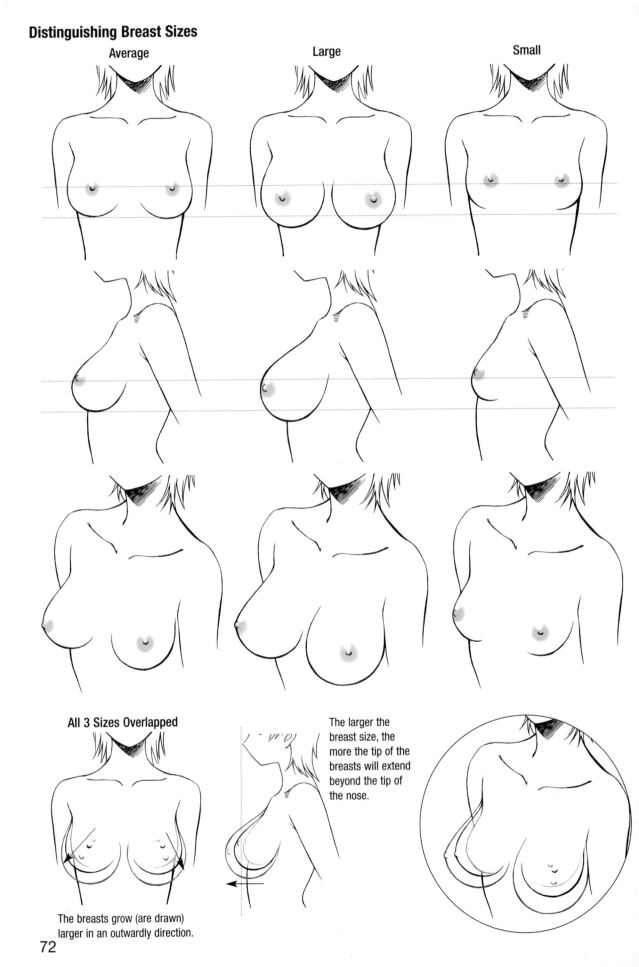

All 3 Sizes Overlapped

The larger the breast size, the more the tip of the breasts will extend beyond the tip of the nose.

The breasts grow (are drawn) larger in an outwardly direction.

When Wearing a T-Shirt

For average-sized breasts, the chest is moderately accentuated

Draw few creases in the clothing for small breasts and deep creases for large breasts. Use hatching, etc. to distinguish the different sizes.

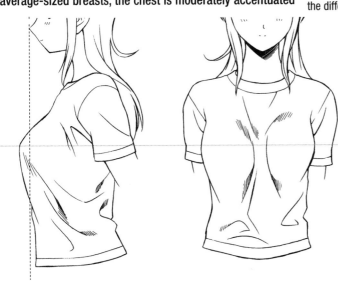
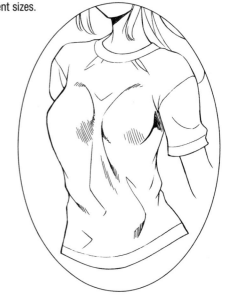

For small breasts, the chest is rendered in typical fashion

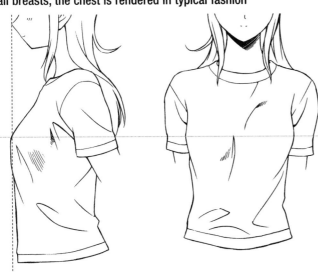
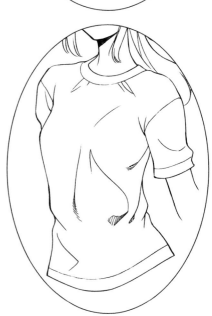

For large breasts, the chest is accentuated to the extreme

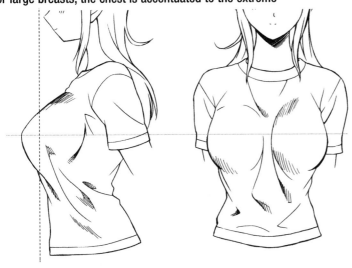
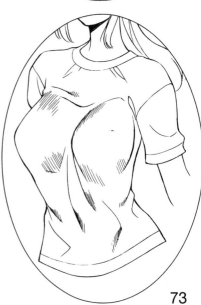

Distinguishing Male and Female Figures

Broaden the shoulders of male characters. The hips should be narrower than the shoulders.

As men and woman have different skin and skeletal structures, care should be taken with the figures' silhouettes.

The hips of a female character should be as wide or wider than the shoulders.

The neck is long and slender.

The torso of a male figure is thicker than that of a female.

While brawny male characters do have beefy thighs, the thigh should never have more girth than the waist.

Accentuating the calf muscles creates a robust look.

Adding lines to the knees to suggest the kneecap evokes a rugged appearance.

The arm is slender and graceful.

The waist is trim and may be drawn with the same girth as that of the fattest part of the thigh.

Depiction of musculature and skeletal structure is often omitted from a female figure's arms, stomach, knees, and legs.

Drawing the arms thick and emphasizing musculature will set a sharp contrast with those of a female figure.

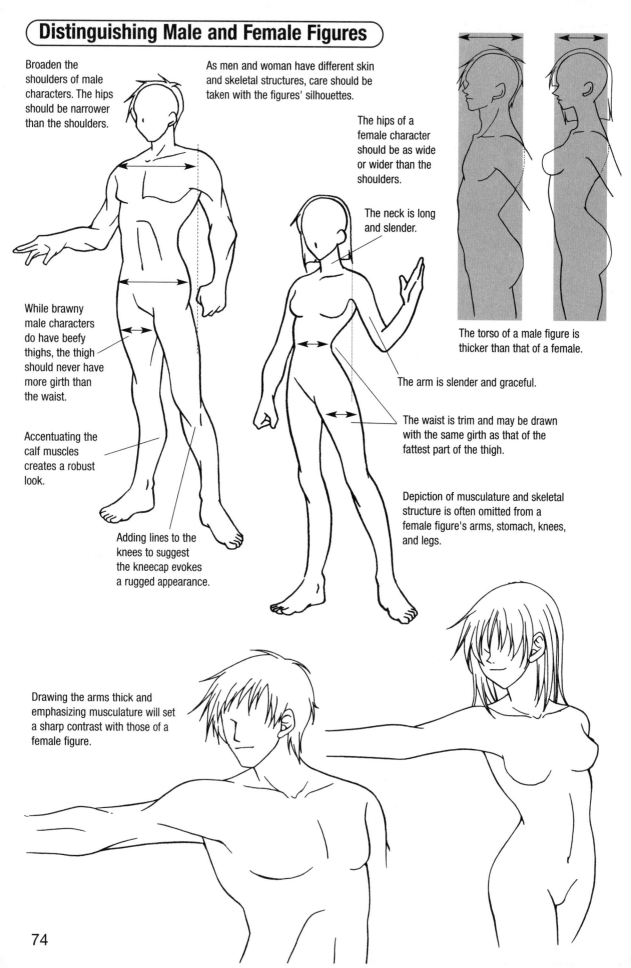

74

Different lines should also be used to draw male and female figures. Use finer lines, applying less pressure to the pen when drawing female figures.

Not good

Here we have a poorly drawn sample, where not only the lines, but also the shoulder blade and the posterior are handled in the manner of a male figure.

Good

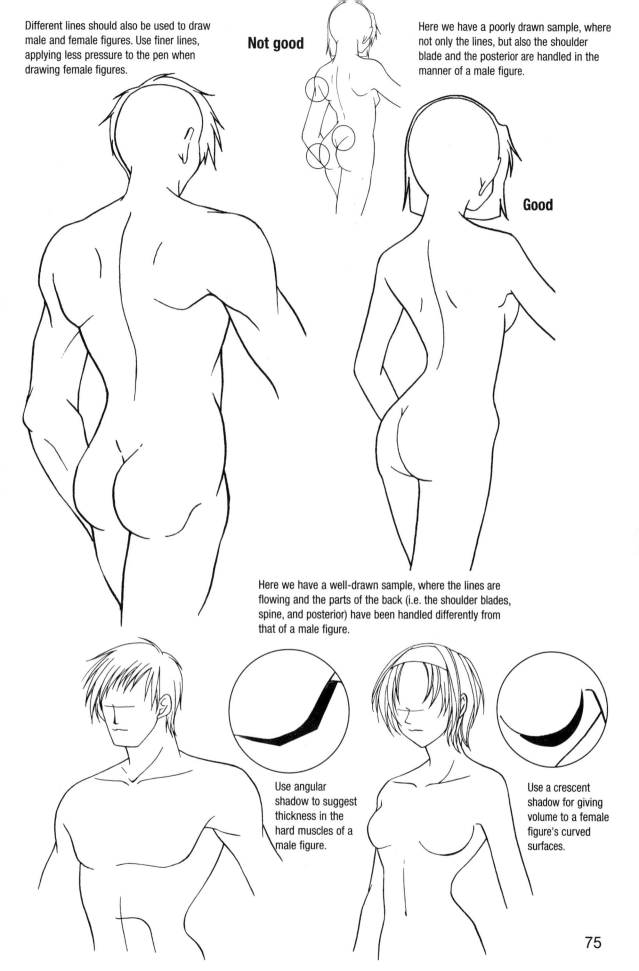

Here we have a well-drawn sample, where the lines are flowing and the parts of the back (i.e. the shoulder blades, spine, and posterior) have been handled differently from that of a male figure.

Use angular shadow to suggest thickness in the hard muscles of a male figure.

Use a crescent shadow for giving volume to a female figure's curved surfaces.

Features to Modify When Drawing Different Male Builds

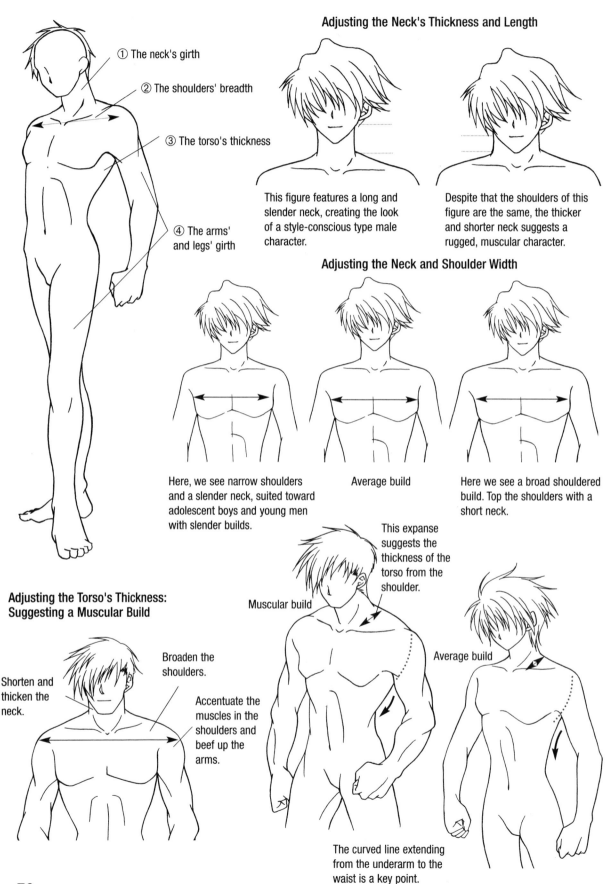

① The neck's girth

② The shoulders' breadth

③ The torso's thickness

④ The arms' and legs' girth

Adjusting the Neck's Thickness and Length

This figure features a long and slender neck, creating the look of a style-conscious type male character.

Despite that the shoulders of this figure are the same, the thicker and shorter neck suggests a rugged, muscular character.

Adjusting the Neck and Shoulder Width

Here, we see narrow shoulders and a slender neck, suited toward adolescent boys and young men with slender builds.

Average build

Here we see a broad shouldered build. Top the shoulders with a short neck.

Adjusting the Torso's Thickness: Suggesting a Muscular Build

Shorten and thicken the neck.

Broaden the shoulders.

Accentuate the muscles in the shoulders and beef up the arms.

Muscular build

This expanse suggests the thickness of the torso from the shoulder.

Average build

The curved line extending from the underarm to the waist is a key point.

Distinguishing Average Builds from Muscular Builds

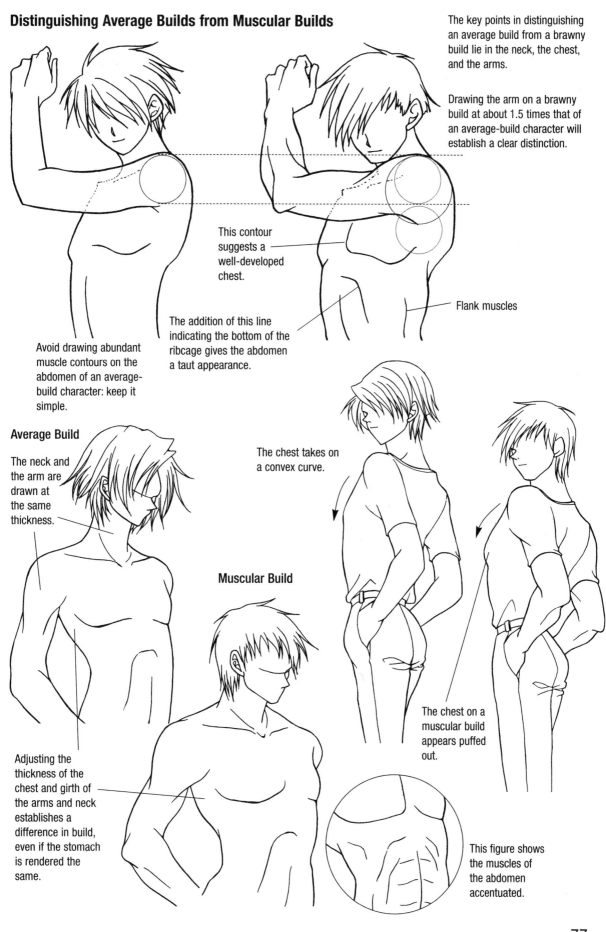

The key points in distinguishing an average build from a brawny build lie in the neck, the chest, and the arms.

Drawing the arm on a brawny build at about 1.5 times that of an average-build character will establish a clear distinction.

This contour suggests a well-developed chest.

The addition of this line indicating the bottom of the ribcage gives the abdomen a taut appearance.

Flank muscles

Avoid drawing abundant muscle contours on the abdomen of an average-build character: keep it simple.

Average Build

The neck and the arm are drawn at the same thickness.

The chest takes on a convex curve.

Muscular Build

The chest on a muscular build appears puffed out.

Adjusting the thickness of the chest and girth of the arms and neck establishes a difference in build, even if the stomach is rendered the same.

This figure shows the muscles of the abdomen accentuated.

Drawing Hands and Feet

Hands

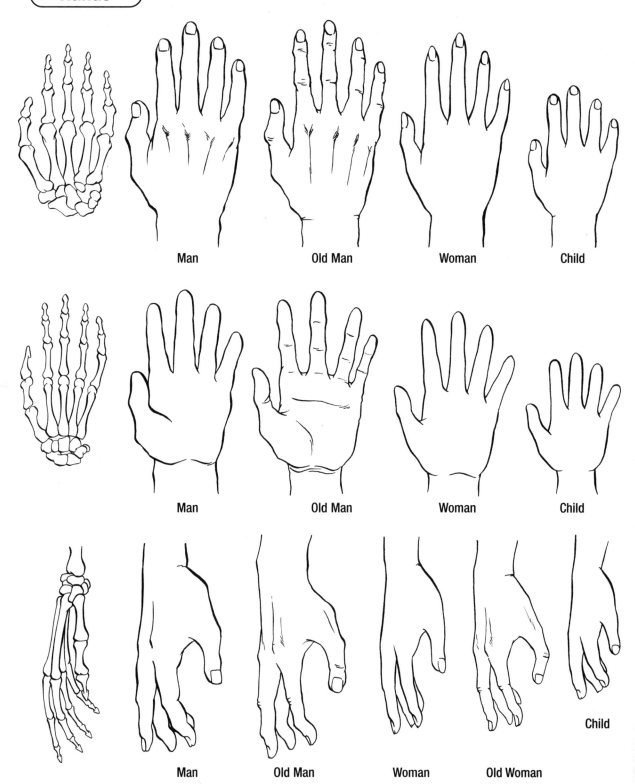

Man Old Man Woman Child

Man Old Man Woman Child

Man Old Man Woman Old Woman Child

Lines Used on the Back of the Hand

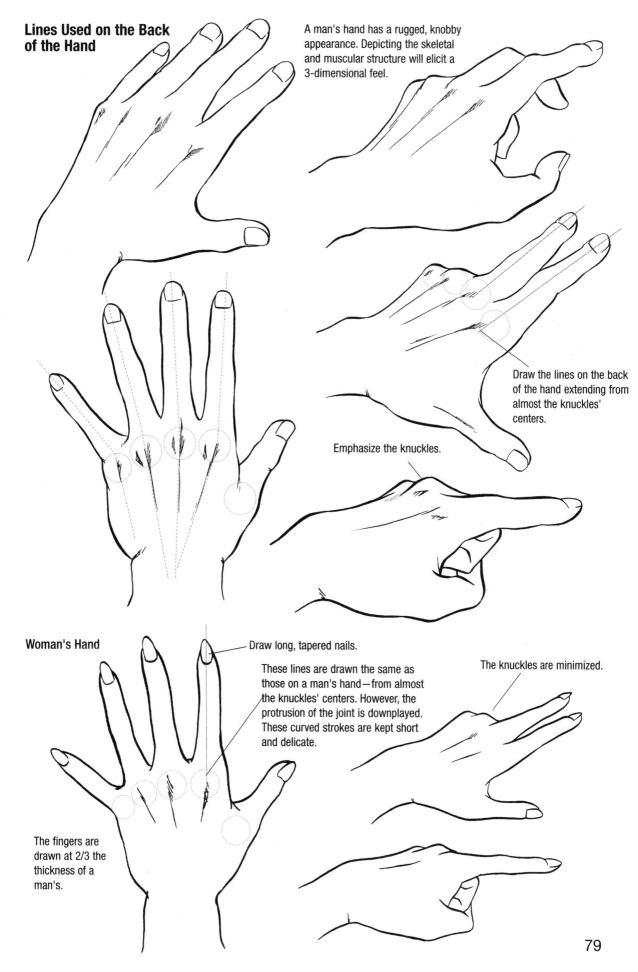

A man's hand has a rugged, knobby appearance. Depicting the skeletal and muscular structure will elicit a 3-dimensional feel.

Draw the lines on the back of the hand extending from almost the knuckles' centers.

Emphasize the knuckles.

Woman's Hand

Draw long, tapered nails.

These lines are drawn the same as those on a man's hand—from almost the knuckles' centers. However, the protrusion of the joint is downplayed. These curved strokes are kept short and delicate.

The knuckles are minimized.

The fingers are drawn at 2/3 the thickness of a man's.

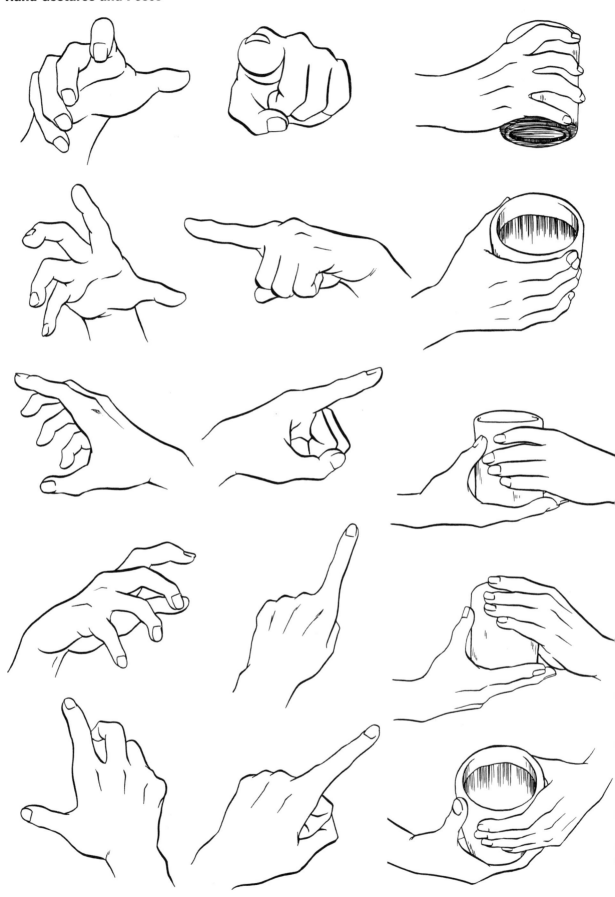

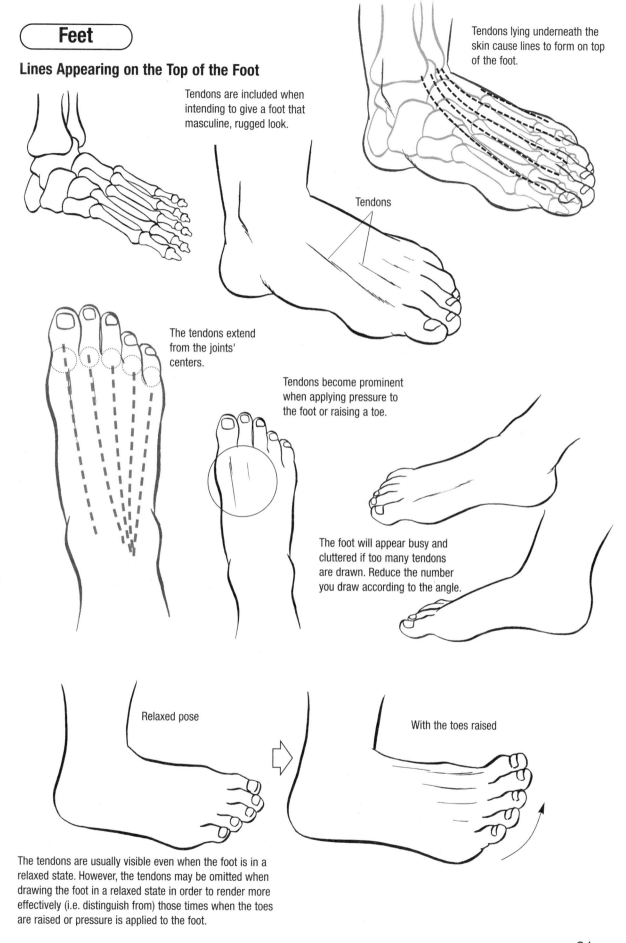

Feet

Lines Appearing on the Top of the Foot

Tendons are included when intending to give a foot that masculine, rugged look.

Tendons lying underneath the skin cause lines to form on top of the foot.

Tendons

The tendons extend from the joints' centers.

Tendons become prominent when applying pressure to the foot or raising a toe.

The foot will appear busy and cluttered if too many tendons are drawn. Reduce the number you draw according to the angle.

Relaxed pose

With the toes raised

The tendons are usually visible even when the foot is in a relaxed state. However, the tendons may be omitted when drawing the foot in a relaxed state in order to render more effectively (i.e. distinguish from) those times when the toes are raised or pressure is applied to the foot.

81

Masculine Feet

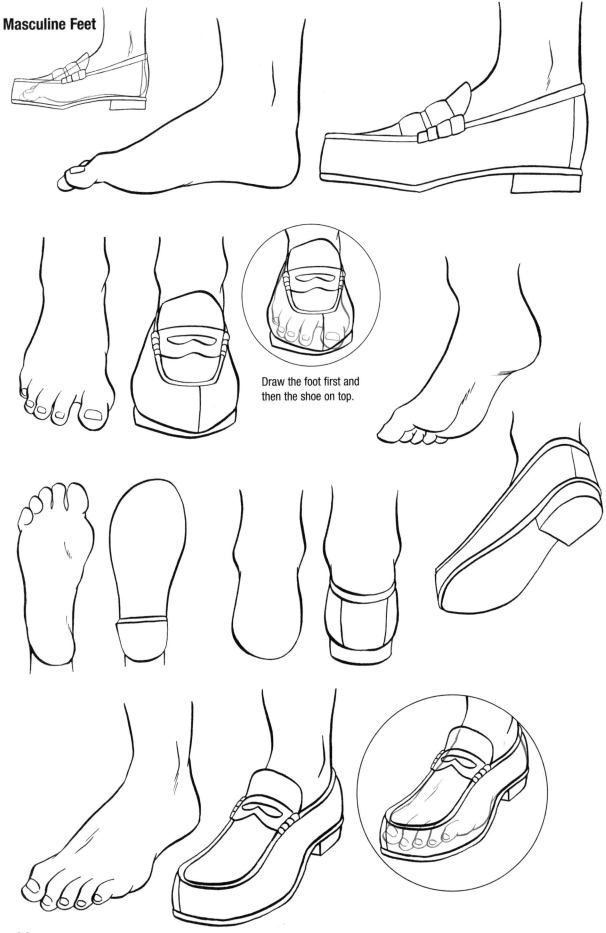

Draw the foot first and then the shoe on top.

82

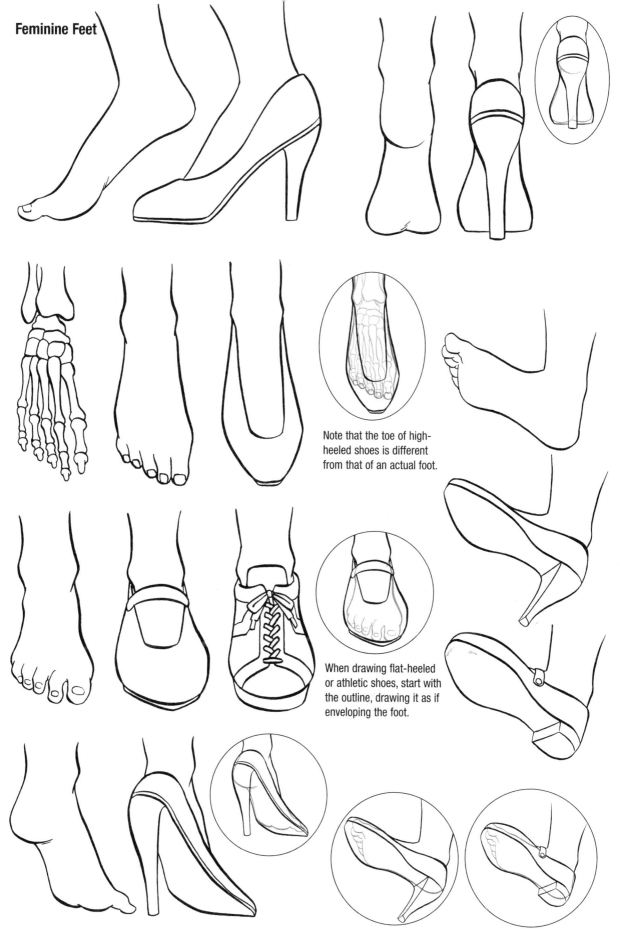

Feminine Feet

Note that the toe of high-heeled shoes is different from that of an actual foot.

When drawing flat-heeled or athletic shoes, start with the outline, drawing it as if enveloping the foot.

Waking Up
Showing Characters Moving (Scene Design and Portrayal)

The 3 key Elemants in a Character Walking

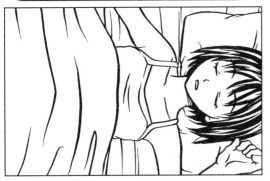

The character asleep.

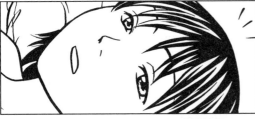

The eyes open.

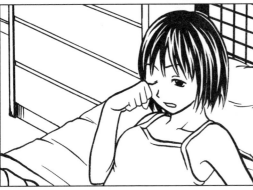

The character rises.

Scenes of a character waking are among the most common in *manga*.

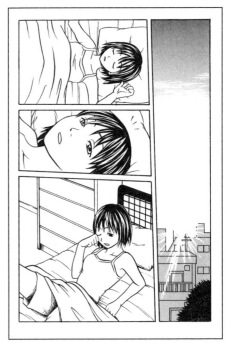

The first page of a *manga* will often include an establishing panel showing the sun rising as its initial panel, indicating that the scene takes place at dawn or in the morning.

Notes
- Shifting angles and movements are also included in these key elements.
- Facial expressions and body language help illustrate the character's personality.

1. The Character Asleep.
- What sort of expression does she wear when sleeping?
- How does she appear when asleep?
- Where and when is she sleeping?

2. The Eyes Open.
- Does she wake up immediately? Or, is she groggy and grumpy?
- In which direction does she sleep?
- Under what circumstances does she awaken? What is her personality?
These points tie into the next element, where the character rises.

3. The Character Rises.
- Is she reluctant to get out of bed?
- Is she cheerful and alert?
- Does she hop out of bed?
- Contrast the character's appearance waking with her appearance sleeping.
These allow you to portray the character's personality.

84

Compositional Samples for a Character Waking

In most cases, *manga* artists have no leeway in allocating scenes of a character waking to a significant number of pages. Such scenes function as an introductory scene for the protagonist or an incident within the story portraying the personality or private life of the protagonist. Scenes like these do not usually extend beyond one page.

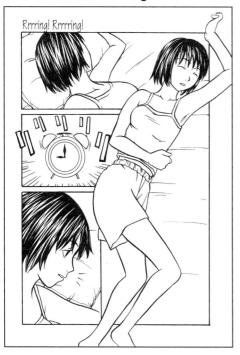

Page with the Sleeping Figure Emphasized

When emphasizing the sleeping figure, the scene is usually drawn up to the character opening her eyes, while the panel of her rising is omitted.

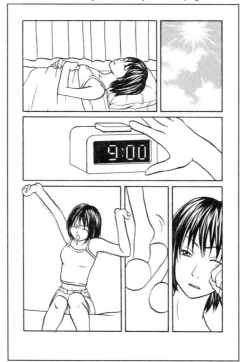

A Leisurely Wake-up

Here we have a peaceful, everyday scene. The first two panels may be condensed into one by omitting the first panel, which portrays "sunlight" or "the sky" and combining it with the second panel to show sunlight falling on the character.

I'm Late!

Scenes like this are primarily used to portray the character waking in a flurry. This is a popular form of portrayal, usually based on the concept that the character overslept.

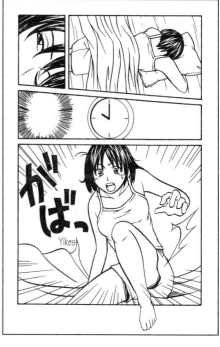

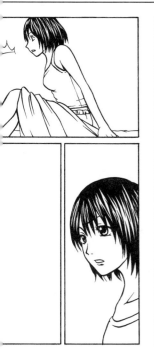

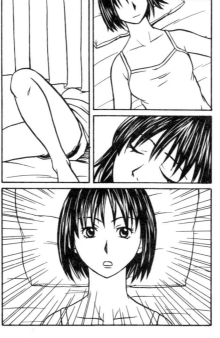

Slowly Unfolding Scene

Scenes like this may take up 2 or more pages. The first scene shows the character asleep and then her eyes opening. The second page shows her rising. This approach is used with full-length *manga* or where "the morning" or "waking" constitutes a major plot development for the story.

Poses: Sleeping

You are not required to show the entire figure when drawing a character sleeping. In fact, it may be more effective not to. Please note, however, that when cropping a figure, draw the portions not visible, beyond the panel's borders as well to ensure the figure is drawn correctly.

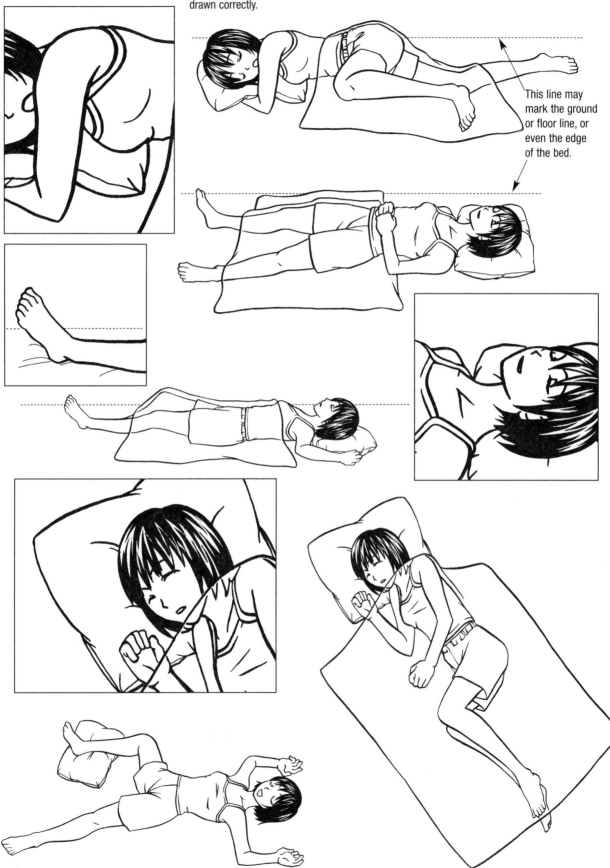

This line may mark the ground or floor line, or even the edge of the bed.

Poses: Rising

①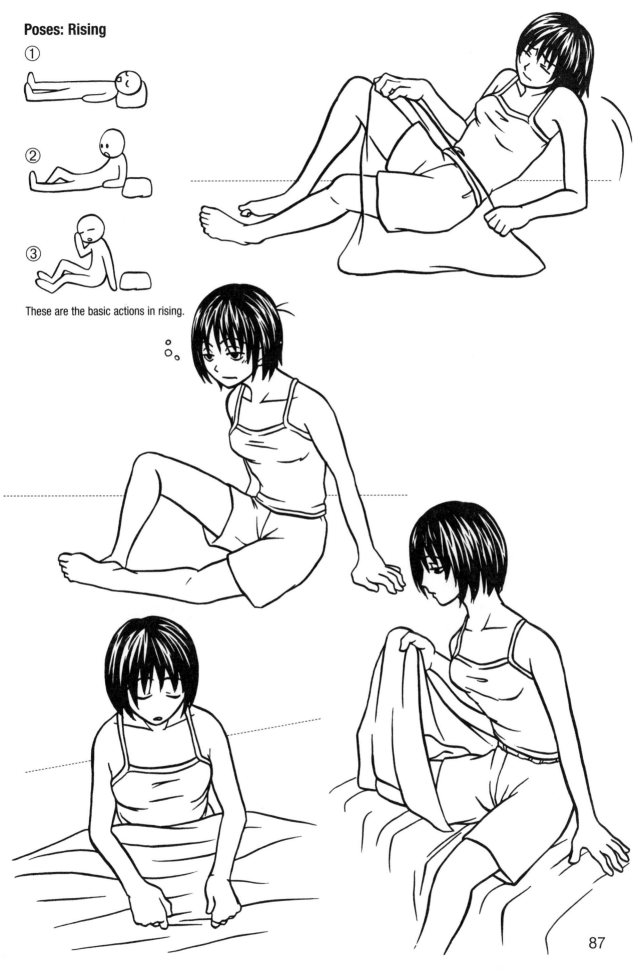

②

③

These are the basic actions in rising.

Sample: A Jolting Wake-up

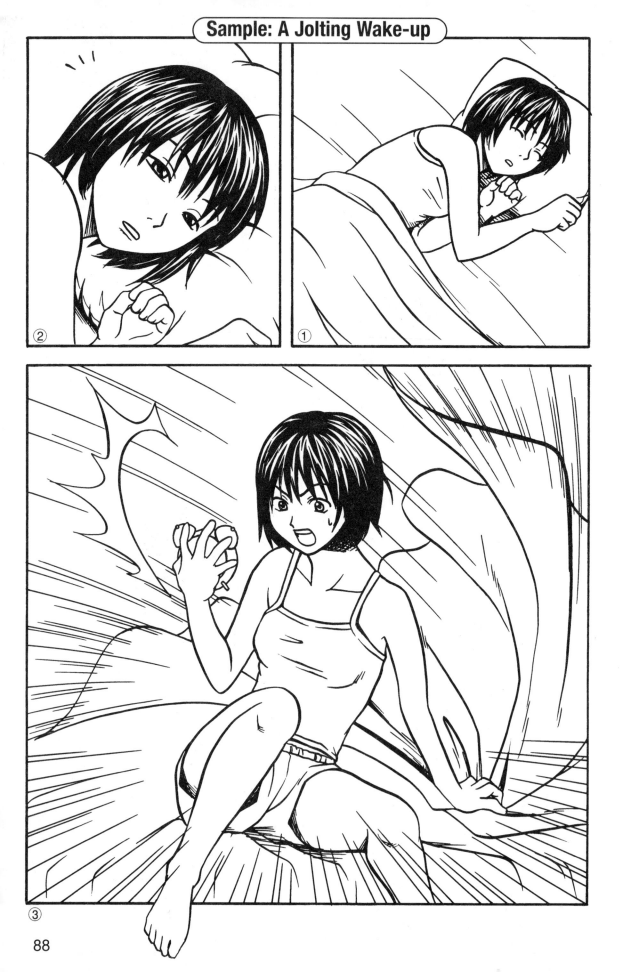

Chapter 3
Facial Expressions

Drawing Any Expression Imaginable

Using the Eyebrows to Portray Facial Expressions

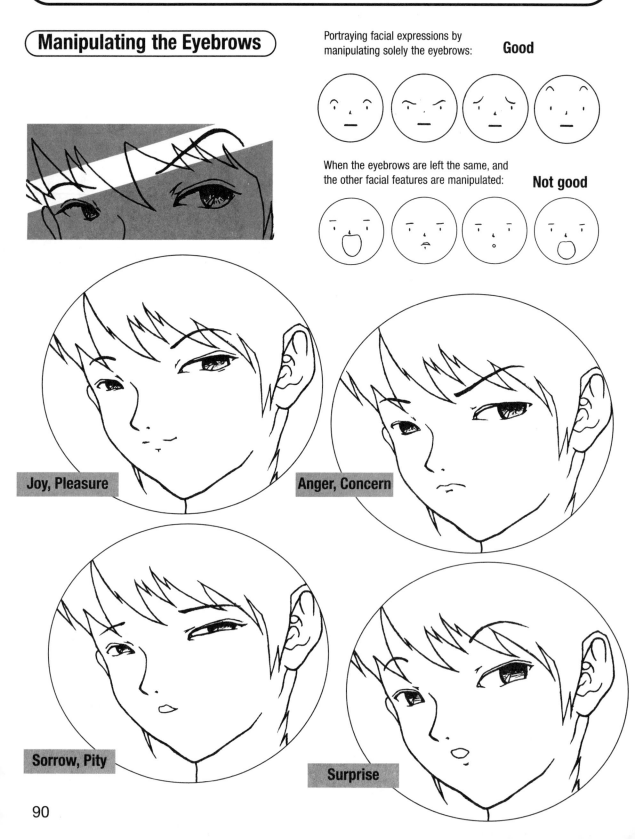

Manipulating the Eyebrows

Portraying facial expressions by manipulating solely the eyebrows: **Good**

When the eyebrows are left the same, and the other facial features are manipulated: **Not good**

Joy, Pleasure

Anger, Concern

Sorrow, Pity

Surprise

Using the Eyebrows to Portray Emotion:
Joy/Pleasure Anger, Sorrow/Pity, Surprise

"Joy, anger, pity, and pleasure" are generally regarded in Japan as the 4 basic emotions. However, there is not much difference between "joy" and "pleasure" when rendered visually. Consequently, I tacked on the much-used-in-*manga* emotion of "surprise."

Joy, Pleasure

Anger, Concern

Sorrow, Pity

Surprise

91

Mouth Movements: Depicting Basic Vowel Sounds

The following are the most common shapes taken by the mouth when expressing a character's emotional state. They are essential to portraying a character full of life.

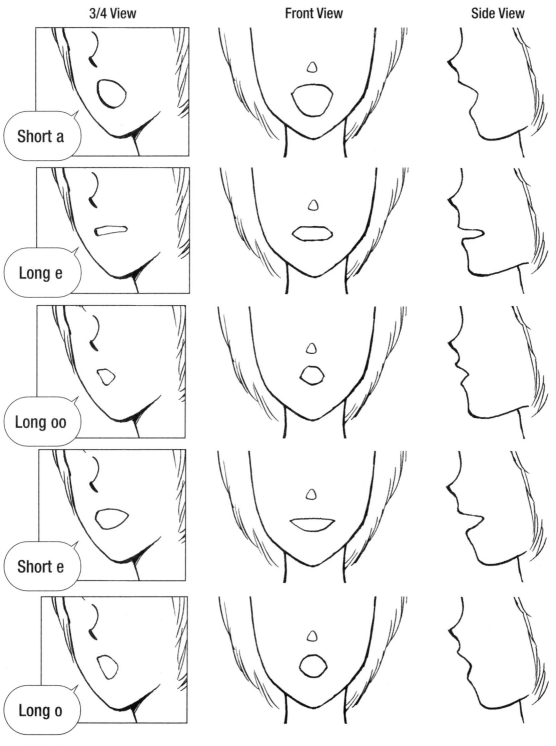

3/4 View

Front View

Side View

Short a

Long e

Long oo

Short e

Long o

Rendering the Mouth's Interior

Anatomy of the Mouth

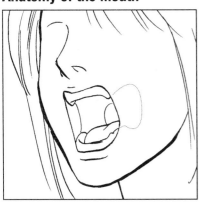

Upper lip

Top row of teeth

Upper jaw (Maxillae)

Throat

Tongue

Bottom row of teeth

Lower lip

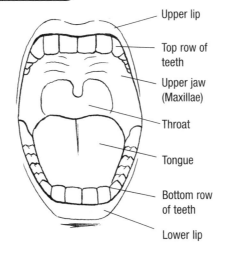

This figure shows the outline of the lips. Portions of the teeth and the mouth's interior are covered by flesh.

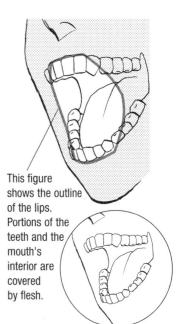

If the skin were removed to reveal the entire mouth, it would look something like this.

Assorted Manga-esque Expressions

When showing the mouth just barely open, draw only the outline of the lips.

Here, the mouth has been rendered solely as an outline. The teeth and tongue have been omitted.

Top teeth only

Tongue only

Top teeth and tongue

Corners of upper lip turned up

Bottom teeth slightly revealed

Realistic mouth: Top and bottom teeth and tongue

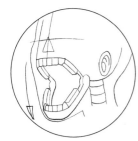

The mouth opens by the lower jaw dropping. The upper jaw does not move.

Speed lines are frequently used when drawing a character yelling.

Screen tone finish (Gradation tone)

Screen tone finish (Dot tone)

93

Close-ups of the Mouth

There are occasions when drawing some of the inside of the mouth is effective in character close-ups.

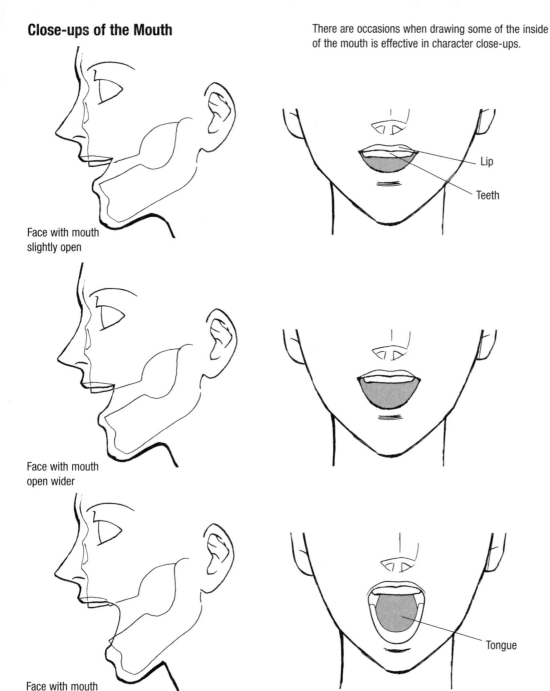

Face with mouth slightly open

Lip

Teeth

Face with mouth open wider

Face with mouth wide open

Tongue

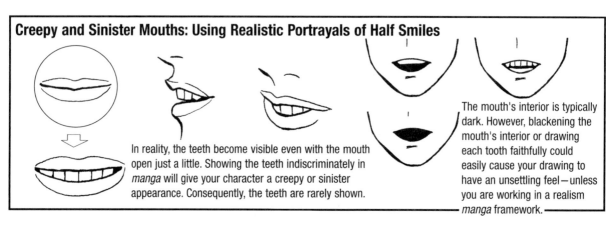

Creepy and Sinister Mouths: Using Realistic Portrayals of Half Smiles

In reality, the teeth become visible even with the mouth open just a little. Showing the teeth indiscriminately in *manga* will give your character a creepy or sinister appearance. Consequently, the teeth are rarely shown.

The mouth's interior is typically dark. However, blackening the mouth's interior or drawing each tooth faithfully could easily cause your drawing to have an unsettling feel—unless you are working in a realism *manga* framework.

Revealing the Teeth:
Exaggeration through Realistic Portrayal

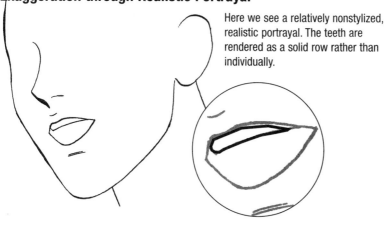

Here we see a relatively nonstylized, realistic portrayal. The teeth are rendered as a solid row rather than individually.

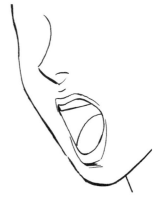

To shout, the mouth opens widely, exposing the bottom teeth and tongue. Use simple lines to render them.

Here we see another shouting mouth. A large expanse of the lower jaw is visible.

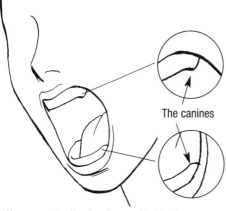

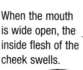

The canines

When the mouth is wide open, the inside flesh of the cheek swells.

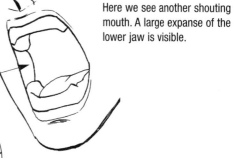

The key is to leave a small space between the contour for the molars and that for the front row of teeth. This will also give the molars their distinctive thickness.

Here, a center line has been added to the tongue, heightening the realism. Since the mouth is wide open, the canines are visible. The canines are often exaggerated when drawing vampires and demons.

Here the mouth is open to the extent possible in a full-throttle yell. The upper jaw, which is in fact stable, appears as if it could move, causing wrinkles to form at the sides of the nose, on the cheeks, and under the eyes. Furrows develop on the brow.

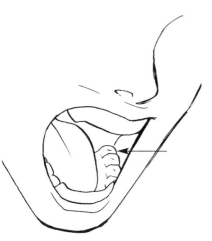

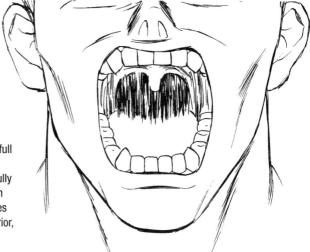

Mouth with molars given thickness

Here we see a mouth open in full shout with the front teeth, the canines, and the molars faithfully rendered. The tongue has been abstracted and diagonal strokes used for the throat's dark interior, resulting in a powerful image.

95

Theatrical Eyes

Standard eye

The upper and lower eyelids move both up and down.

Normally, when the eye is closed, the eyelashes form a downward curve.

When the eye is squeezed shut, the eyelashes take on an upward curve, and creases form around the eye.

Changing the Size of the Eyes for Emotion Portrayal

Wide open eyes

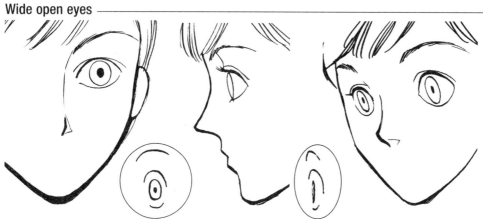

Manga-style facial expression

Half-closed eyes

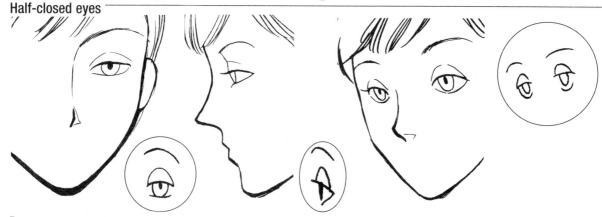

Droopy eyes

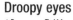

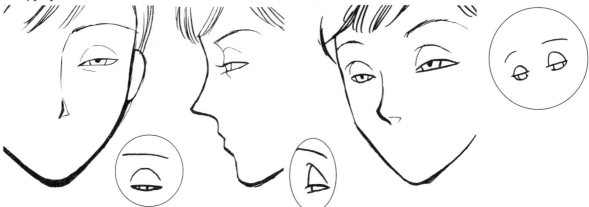

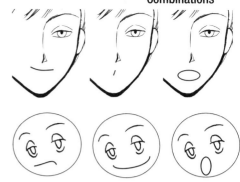

Standard eye Half-closed eye Normally closed eye Eye squeezed shut

Adjusting the shape or position of the mouth allows for a variety of facial expressions, even when paired with the same eyes and eyebrows.

Various Expressions with the Eyes Closed

Laughing/smiling

Normal state

Eyes squeezed shut

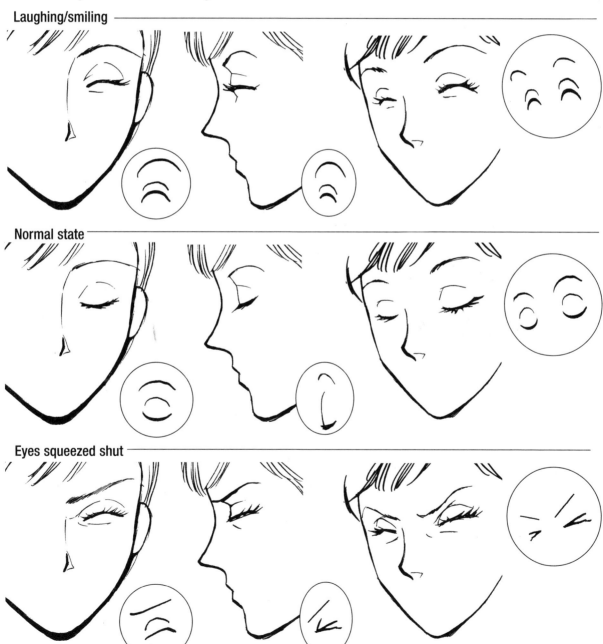

97

Uses of Showing the Eyes Closed

Maintaining the face in the same direction and at the same angle but changing the hair and the background makes this face adaptable to any number of scenes.

3/4 View

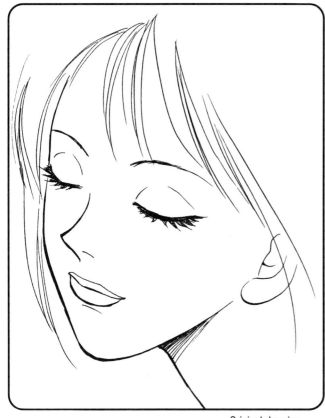

Original drawing

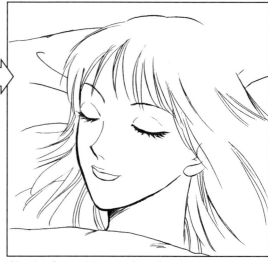

Sleeping Scene: Adjust the flow of the hair and draw a mattress edge and pillow creases.

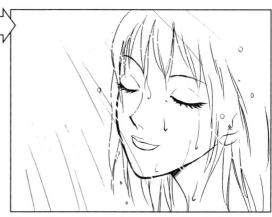

Shower Scene: Draw water or perspiration droplets. Show the hair clinging to the face to suggest wet hair.

Wink

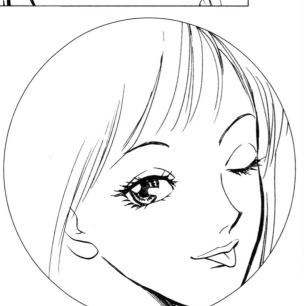

Eating Scene: Add chopsticks and a morsel of food.

Side View Drawing a side view on a diagonal or horizontally suggests that the character is lying down or reclining.

Here is the original drawing. I rotated it to a diagonal or till the head appeared lying down, setting up scenes of the character "nodding in acknowledgement," "sleeping," "eating," and "reading."

Sleeping: I flipped the original drawing on its side and drew part of a comforter.

Here is the character nodding in acknowledgement (greeting). I used the same angle (with respect to the panel) for the eating and reading panels.

Pleased to meet you

Nodding in acknowledgement

Eating: I drew a hand and fork, and added a line to the mouth to suggest chewing.

Reading: I simply added a book and a hand.

Practical Application: Showering

In this figure, I adjusted the eyes and the mouth to suggest a smiling expression and drew the hair as if flowing in a breeze.

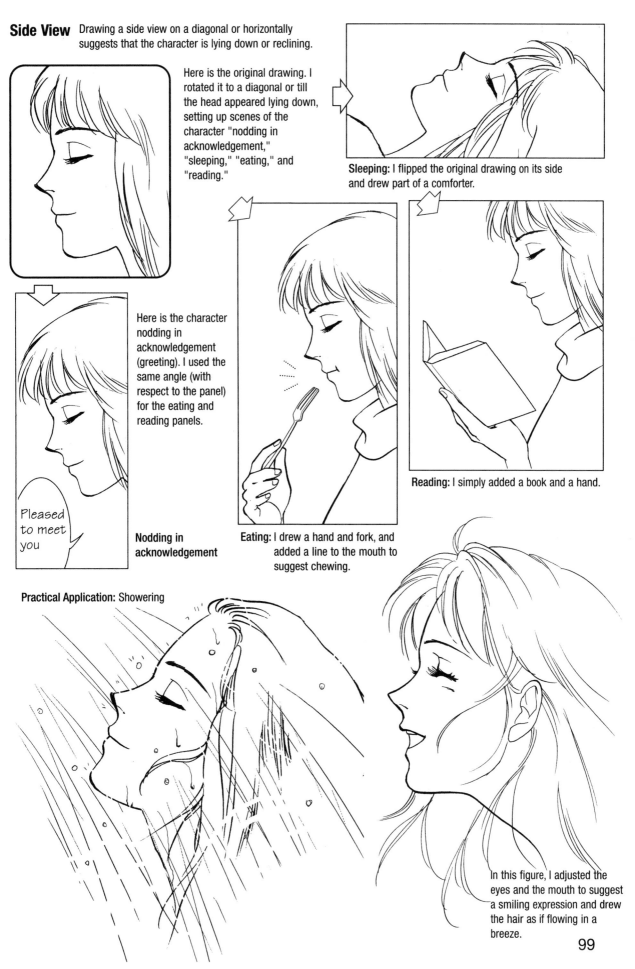

Combining Features to Express Emotions
Sample Emotions and Subtle Expressions Created by Combining Features

Closing One Eye

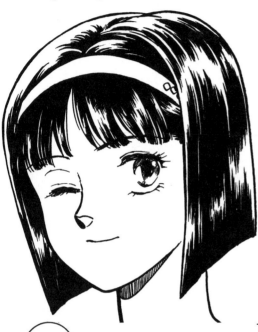

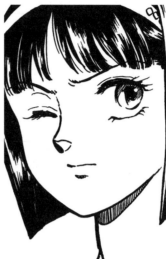

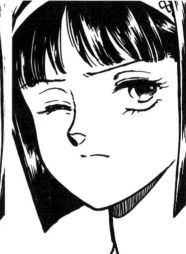

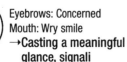
Eyebrows: Smiling
Mouth: Smiling
→**Wink**

Eyebrows: Angry
Mouth: Smiling
→**Struggling for patien**

This expression could change dramatically by slightly altering the angle or adjusting the size of the mouth.

Eyebrows: Angry
Eyes: Half closed
Mouth: Angry
→**Looking displeased, reproachful**

Adjusting the Size of the Eyes
Showing One Eye Slightly Closed

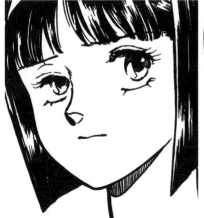

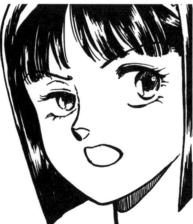

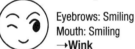
Eyebrows: Concerned
Mouth: Wry smile
→**Casting a meaningful glance, signali**

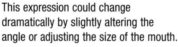
Eyebrows: Asymmetrical
Mouth: Open
→**Objecting, complainin**

Eyebrows: Angry
Eyes: Both half closed
Mouth: Smiling
→**Smiling scornfully, jeering**

100

Using Eye Movement to Express Emotions

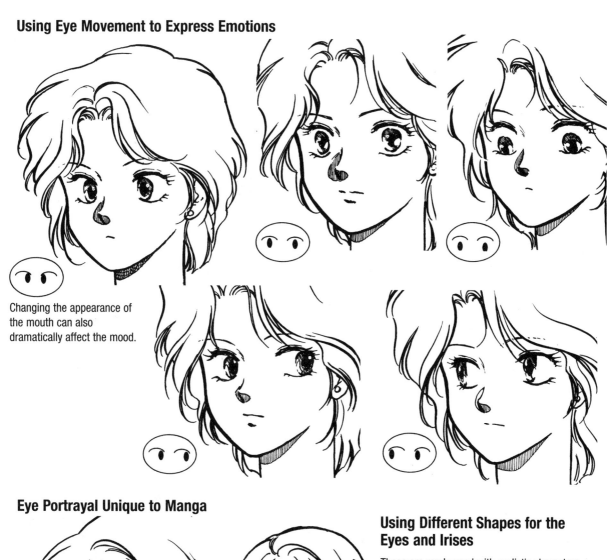

Changing the appearance of the mouth can also dramatically affect the mood.

Eye Portrayal Unique to Manga

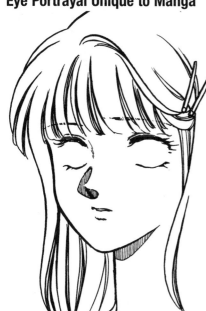

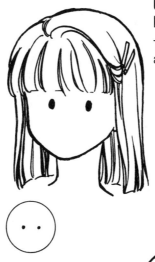

Blank Eyes
Often used in close-ups, these are used to show dumbfounderment, shock, or a glazed, vacant look.

Dots
Used with small images, these illustrate a flabbergasted, dumbfounded, disgusted expression.

Using Different Shapes for the Eyes and Irises

These are rarely used with realistic characters and are suited toward smaller images.

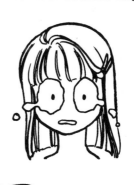

Crying: Tears

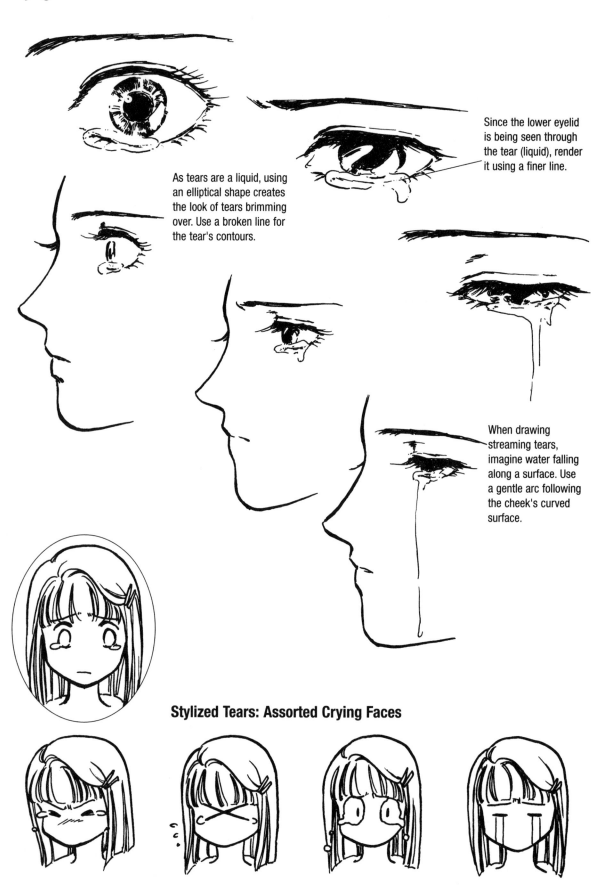

As tears are a liquid, using an elliptical shape creates the look of tears brimming over. Use a broken line for the tear's contours.

Since the lower eyelid is being seen through the tear (liquid), render it using a finer line.

When drawing streaming tears, imagine water falling along a surface. Use a gentle arc following the cheek's curved surface.

Stylized Tears: Assorted Crying Faces

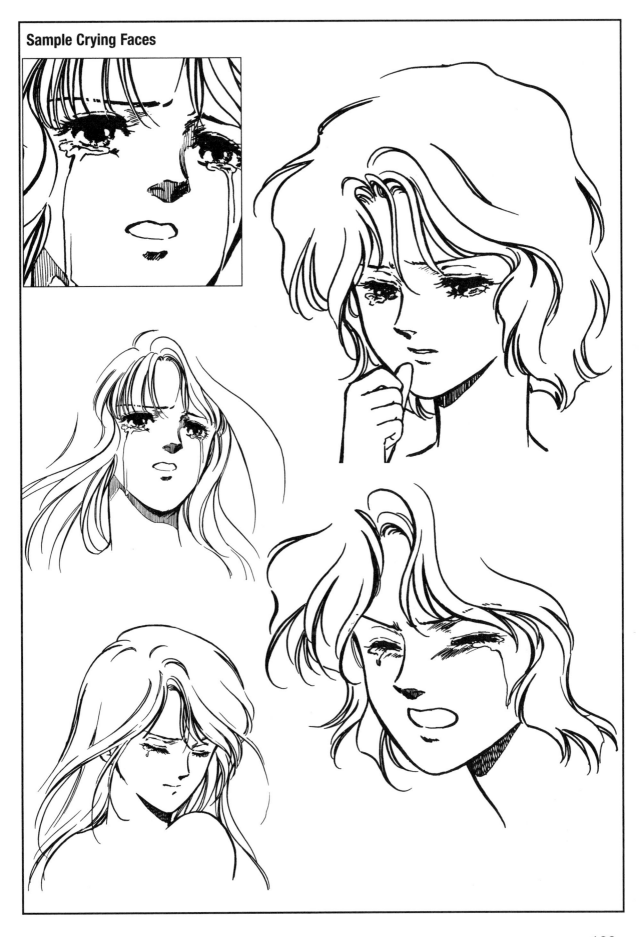

Symbolic Representation of Emotion

 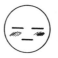 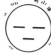 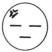

Vertical Lines

- Express tension, unease, and the depth of emotion
- Can be used in dramatic as well as humorous situations

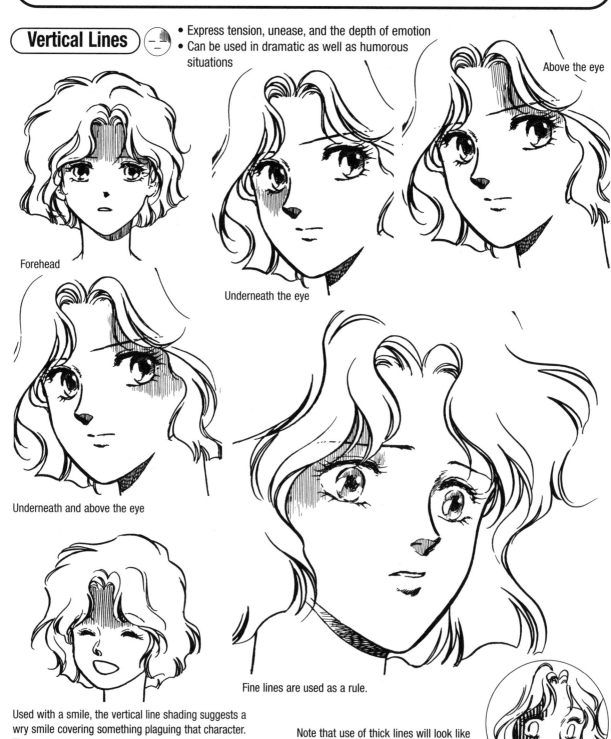

Above the eye

Forehead

Underneath the eye

Underneath and above the eye

Fine lines are used as a rule.

Used with a smile, the vertical line shading suggests a wry smile covering something plaguing that character. The vertical lines belie the smile.

Note that use of thick lines will look like some sort of decorative patterning on the character's face.

 Perspiration • Express tension, unease, and the depth of emotion
• Can be used in dramatic as well as humorous situations

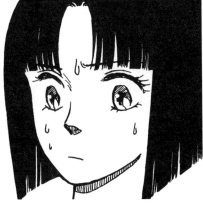

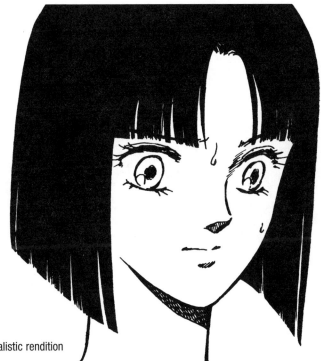

Comical rendition

Realistic rendition

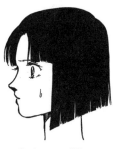

Serious rendition

A single, large sweat bead
used for a comical rendition

Combination of sweat
bead and vertical lines

105

- Used to express realization or surprise
- Can also be used with a smile or to express joy or cheerfulness

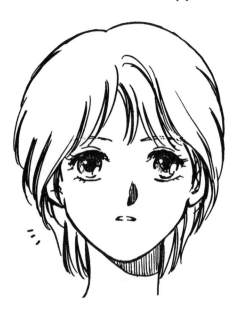

While there are no set rules regarding the number of dashes or where they are placed, about 3 to 4 lines works fine.

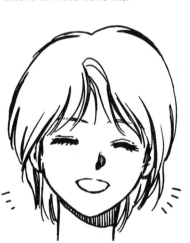

Drawing dashes on both sides suggests joyful cheer.

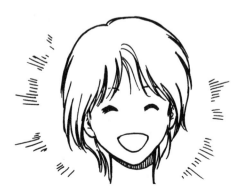

Too many lines may cause their intended significance to become vague.

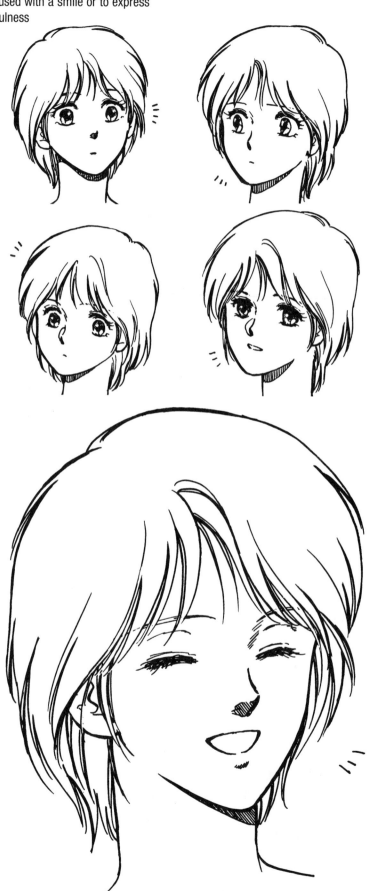

106

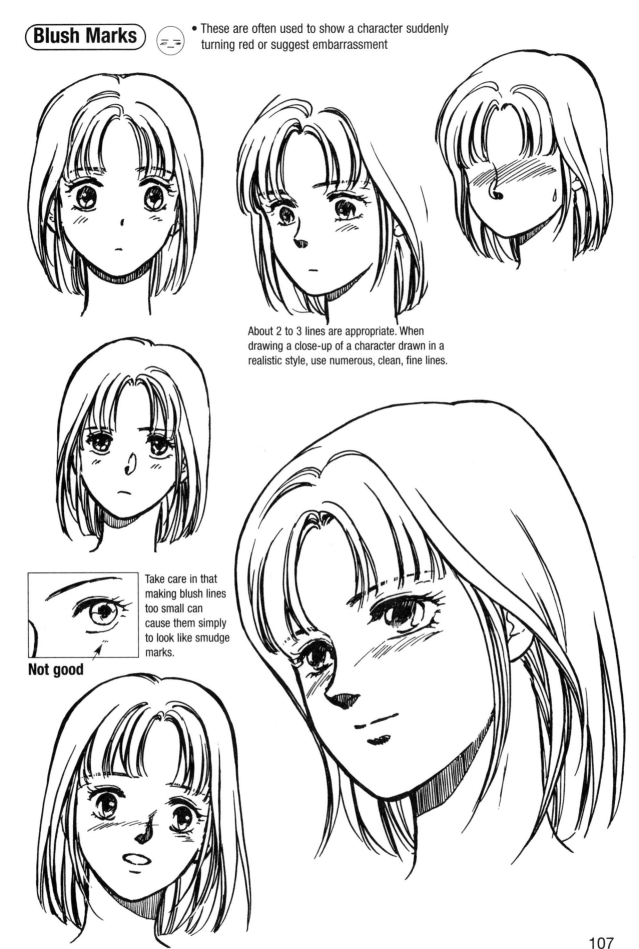

Blush Marks

• These are often used to show a character suddenly turning red or suggest embarrassment

About 2 to 3 lines are appropriate. When drawing a close-up of a character drawn in a realistic style, use numerous, clean, fine lines.

Take care in that making blush lines too small can cause them simply to look like smudge marks.

Not good

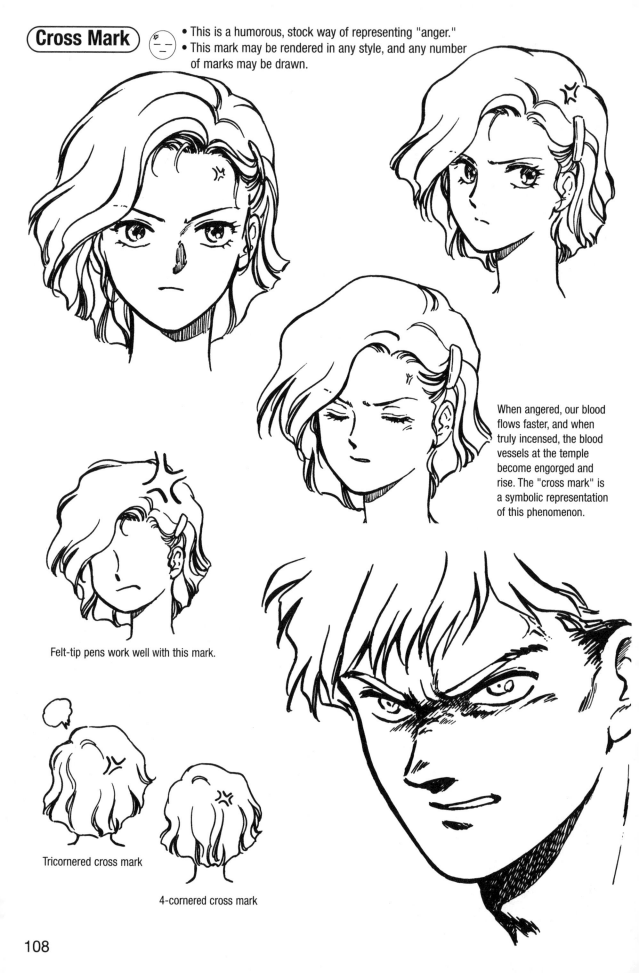

Cross Mark

- This is a humorous, stock way of representing "anger."
- This mark may be rendered in any style, and any number of marks may be drawn.

When angered, our blood flows faster, and when truly incensed, the blood vessels at the temple become engorged and rise. The "cross mark" is a symbolic representation of this phenomenon.

Felt-tip pens work well with this mark.

Tricornered cross mark

4-cornered cross mark

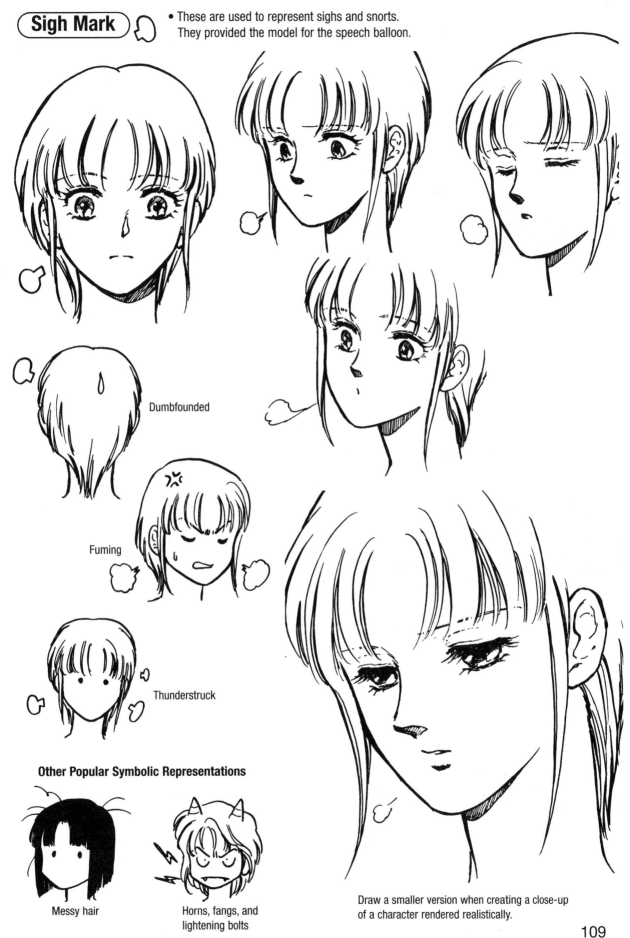

Sigh Mark

• These are used to represent sighs and snorts.
They provided the model for the speech balloon.

Dumbfounded

Fuming

Thunderstruck

Other Popular Symbolic Representations

Messy hair

Horns, fangs, and
lightening bolts

Draw a smaller version when creating a close-up
of a character rendered realistically.

Using the Mouth to Show Emotion

Short a **Long e**

Standard Mouths

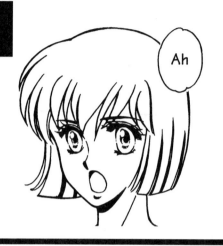

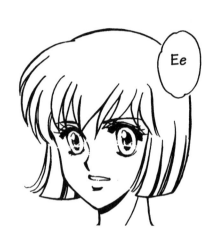

Surprise

Surprise Suggested Using the Eyes and Eyebrows

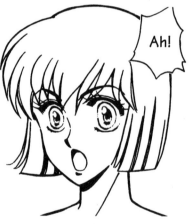

Exaggerating the Mouth

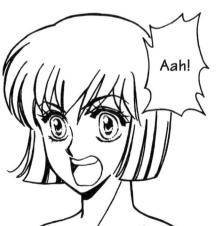

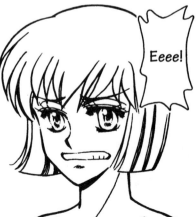

Standard face

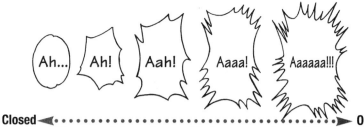

Ah... | Ah! | Aah! | Aaaa! | Aaaaaa!!!

Closed ◄••••••••••••••••••••••••••••••••••► Open

The size and shape of a speech balloon change along with the intensity of emotion. The stronger the emotion, the larger and more exaggerated the mouth, and the larger the speech balloon and copy inside.

Long oo ## Short e ## Long o

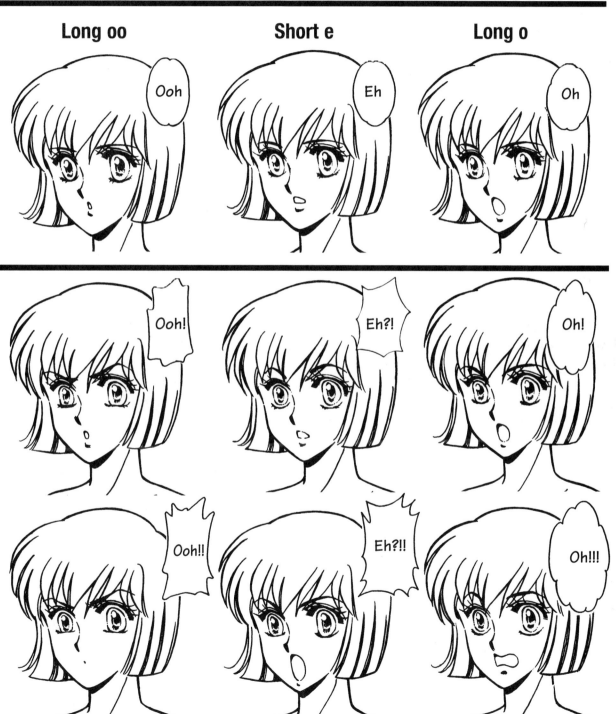

**Face with
Perspiration,
Blush Marks,
and Vertical
Lines**

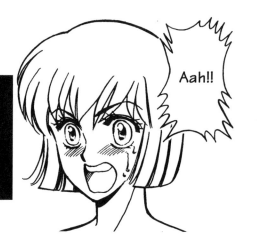 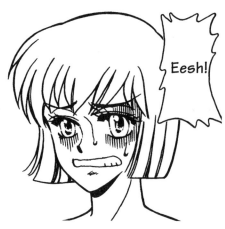

**Below-the-
Neck
Movement and
Hand Gestures**

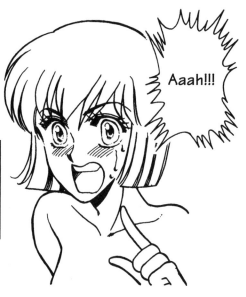 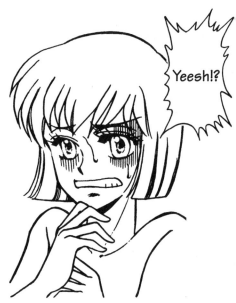

Smiling Faces

**Common
Smiling Faces**

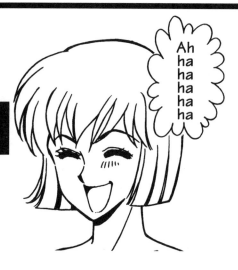

"Tee hee hee" etc. may also be used.

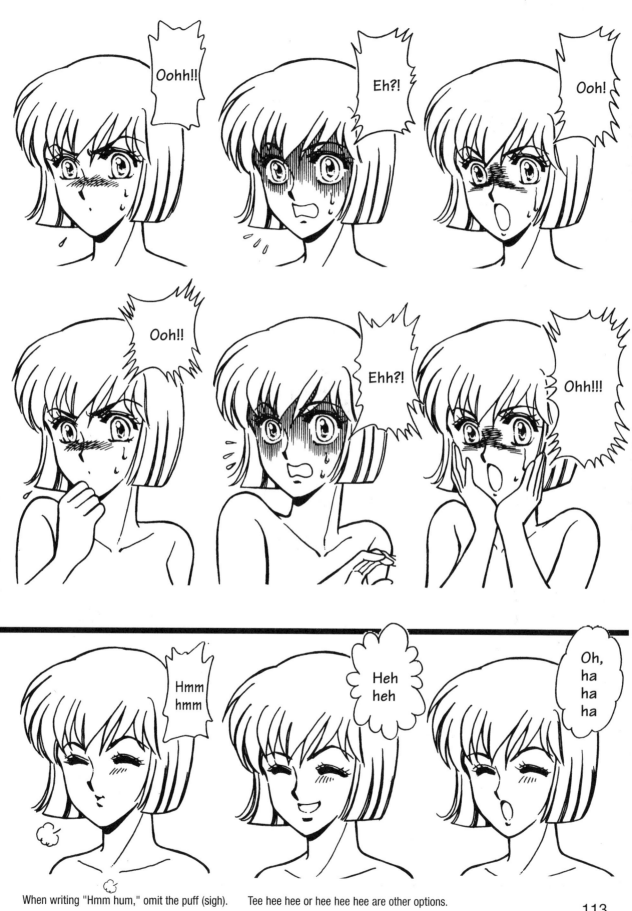

When writing "Hmm hum," omit the puff (sigh). Tee hee hee or hee hee hee are other options.

113

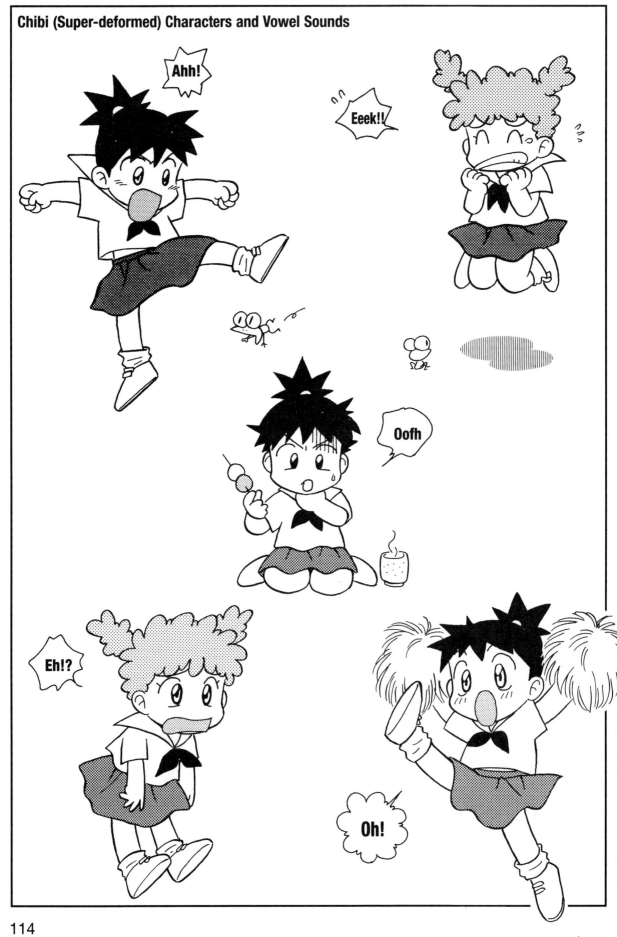

Chapter 4
Manga Miscellaneous

Creating Key Images and Character Entrance Scenes

When drawing key images and character entrance scenes, do not just simply make your subject large, but rather draw a pose, showing the character leaning against an object. The image will carry even more impact if you keep vague against exactly what the character is leaning.

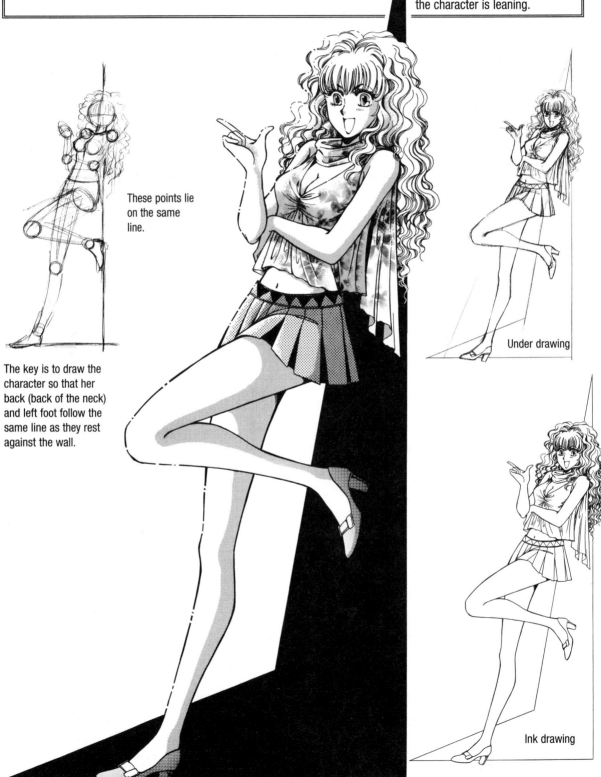

These points lie on the same line.

The key is to draw the character so that her back (back of the neck) and left foot follow the same line as they rest against the wall.

Under drawing

Ink drawing

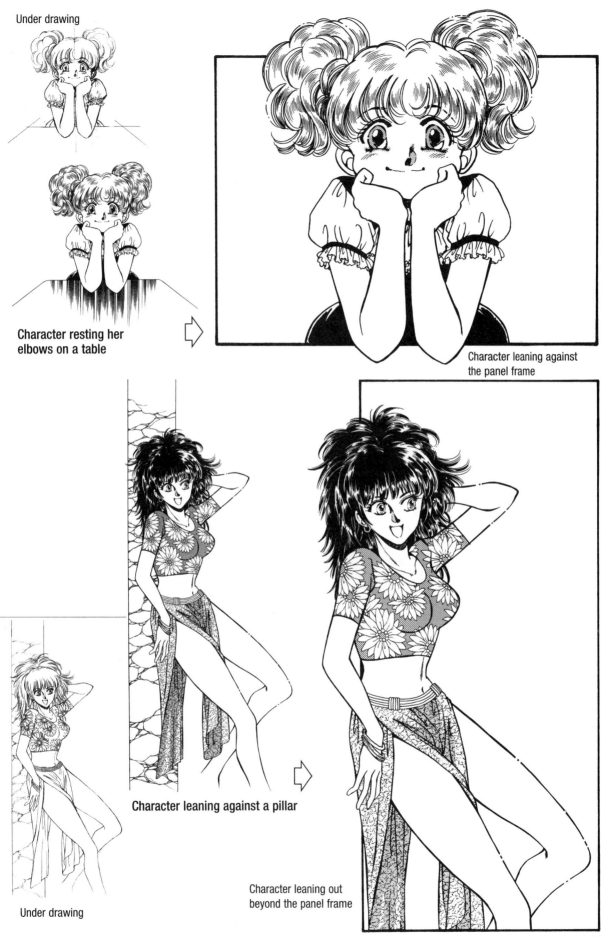

Under drawing

Character resting her elbows on a table

Character leaning against the panel frame

Character leaning against a pillar

Under drawing

Character leaning out beyond the panel frame

Vehicles and Figures: Driving Scenes

When illustrating a character driving, you are often portraying scenes where the character would actually be hidden by the car's roof or hood (i.e. when the figure would not appear in a photograph). Check out angles and shots used in movies and TV dramas for pointers.

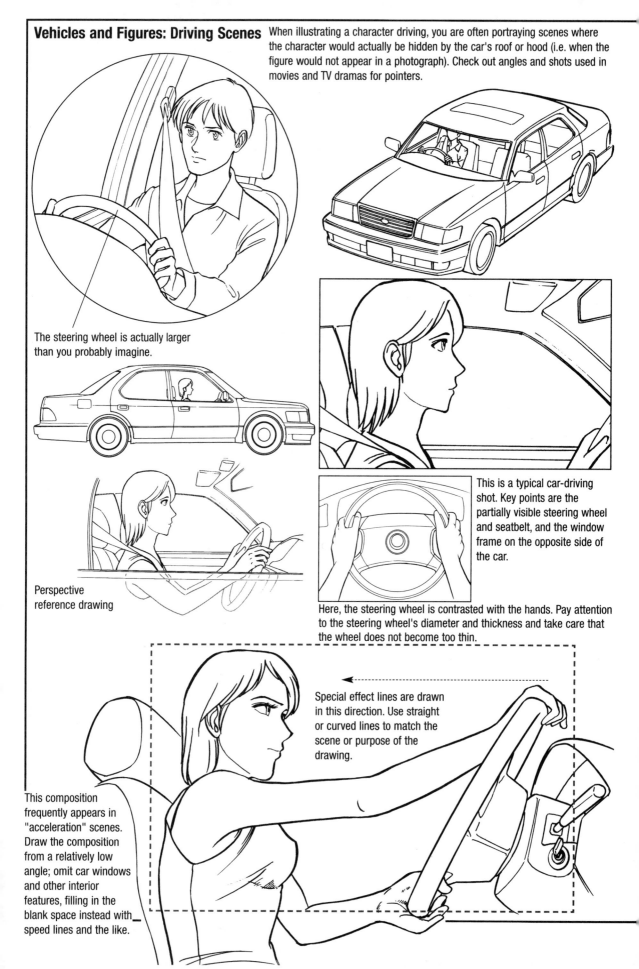

The steering wheel is actually larger than you probably imagine.

Perspective reference drawing

This is a typical car-driving shot. Key points are the partially visible steering wheel and seatbelt, and the window frame on the opposite side of the car.

Here, the steering wheel is contrasted with the hands. Pay attention to the steering wheel's diameter and thickness and take care that the wheel does not become too thin.

Special effect lines are drawn in this direction. Use straight or curved lines to match the scene or purpose of the drawing.

This composition frequently appears in "acceleration" scenes. Draw the composition from a relatively low angle; omit car windows and other interior features, filling in the blank space instead with speed lines and the like.

When Both a Driver and Passenger Are Present

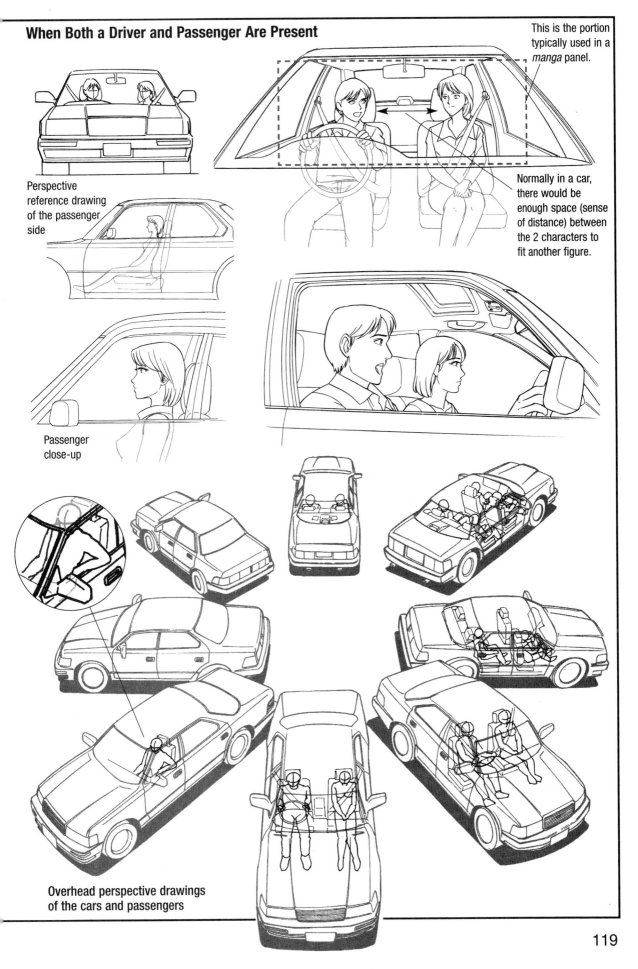

This is the portion typically used in a *manga* panel.

Normally in a car, there would be enough space (sense of distance) between the 2 characters to fit another figure.

Perspective reference drawing of the passenger side

Passenger close-up

Overhead perspective drawings of the cars and passengers

Suggesting Movement Using a Single Panel: Glancing Back

Taking Notice and Glancing Back

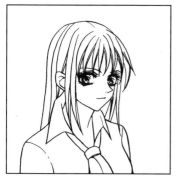

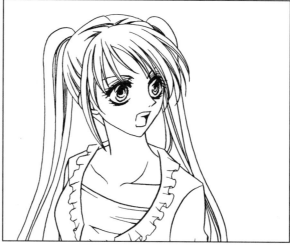

Here, rather than showing physical movement, only the gaze is shifting. Repetition of similar cuts would result in bland *manga*; however, since compositions like this do seem to carry significance, artists tend to lure themselves into thinking they are showing movement. This is a common trap for beginning artists.

Dashes are a standard means of indicating "taking notice."

As the face and body are facing different directions, movement is given to the composition. This combination is used both for "taking notice" and "looking back."

● The Most Common Ingredient of "Taking Notice" and "Looking Back": Showing the Back and Face

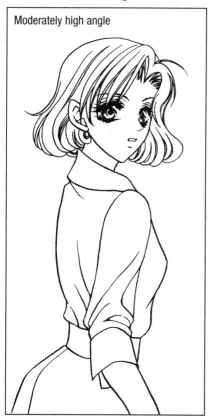

Moderately high angle

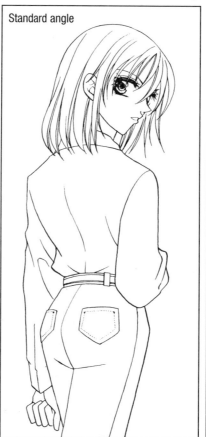

Standard angle

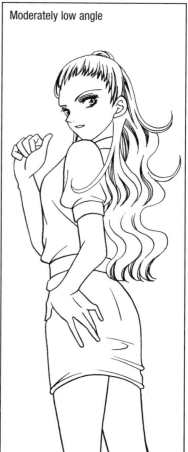

Moderately low angle

• The Gaze and Flow of the Hair Evoke a Sense of Movement

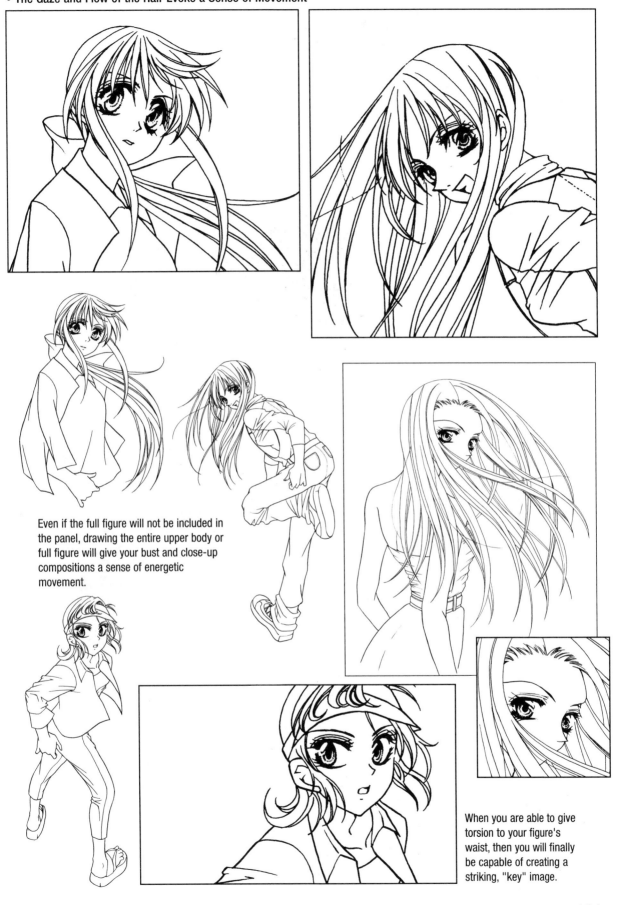

Even if the full figure will not be included in the panel, drawing the entire upper body or full figure will give your bust and close-up compositions a sense of energetic movement.

When you are able to give torsion to your figure's waist, then you will finally be capable of creating a striking, "key" image.

Penning Techniques That Create Depth

Give you compositions depth by contrasting light and shadow and modulating edges.

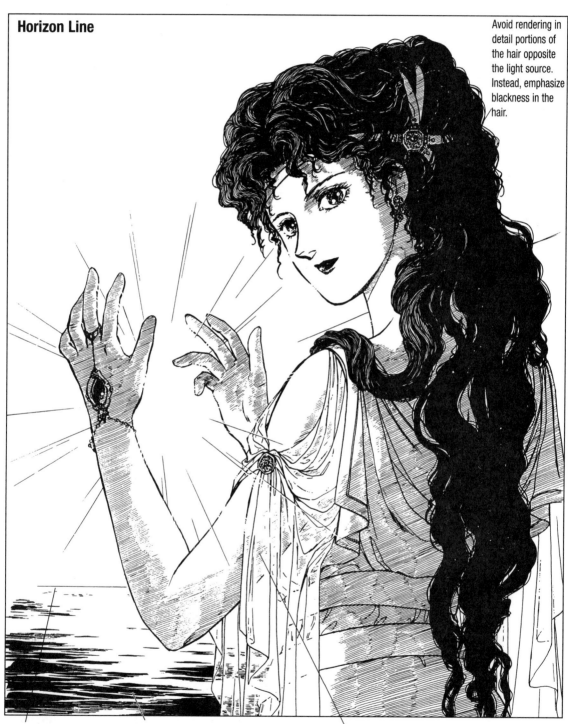

Horizon Line

Avoid rendering in detail portions of the hair opposite the light source. Instead, emphasize blackness in the hair.

Using a finer line for the horizon than for the figure will generate a sense of depth.

Using a finer line for the horizon than for the figure will generate a sense of depth.

Reducing the concentration of diagonal strokes used for shading in the gossamer lace will give a sense of volume to the "closer" lace.

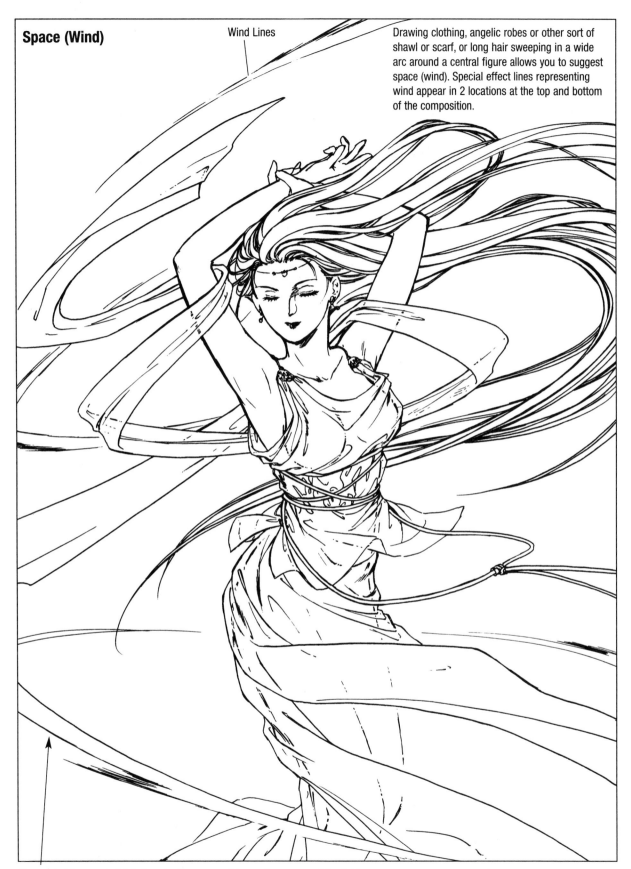

Space (Wind)

Wind Lines

Drawing clothing, angelic robes or other sort of shawl or scarf, or long hair sweeping in a wide arc around a central figure allows you to suggest space (wind). Special effect lines representing wind appear in 2 locations at the top and bottom of the composition.

These wind lines, not visible in actuality, are used to create a sense of the "air's density" or speed. The lines can be rendered in various forms, be it straight or curved. Here, sweeping arcs are used to suggest air swirling. Having the wind lines become finer as they wrap around toward the back of the figure allows the lines themselves to give the composition a sense of depth.

Water Droplets

The key point here is the contrast between the sizes of the water droplets and splash. In the foreground, a large wave and a large splash of water appear in the foreground to suggest "proximity." The tiny circle centered at the woman's face is in fact a water droplet. The contrast between the small water droplets and the large splash create a sense of space and depth.

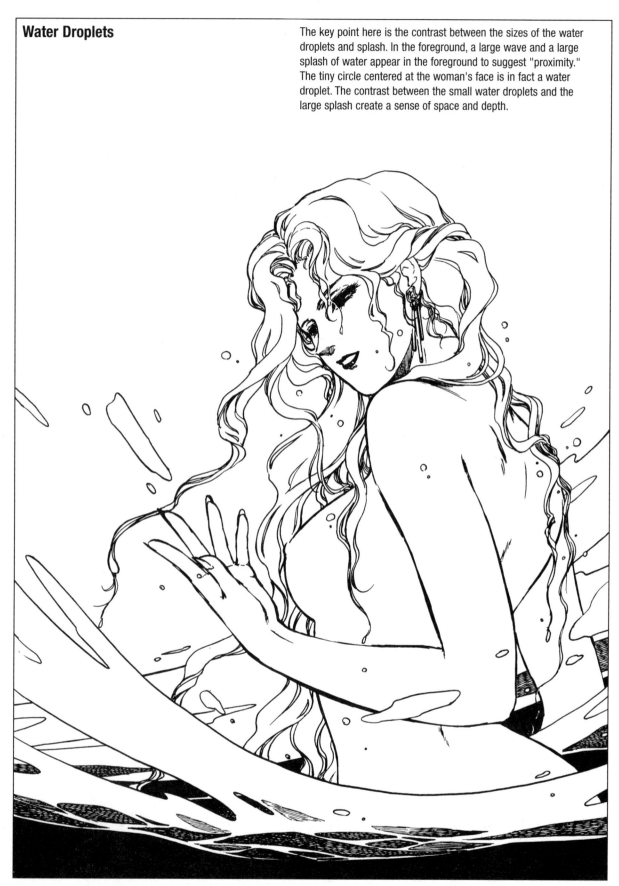

The contrast between black, white, and greys form the water's surface. Hatching was used for the greys.
A key point is the shapes used for the mosaic water pattern formed by reflected light. Since this is still
a liquid surface, geometric patterns drawn using curved lines were used to suggest the waves' undulations.

Making Corrections

White Paint Diluted with Water: Water-based White Paint

White poster paint

Misnon

Misnon W-20
For use with
permanent ink

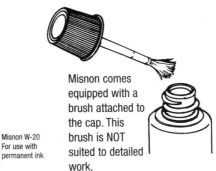

Misnon comes
equipped with a
brush attached to
the cap. This
brush is NOT
suited to detailed
work.

Note: Too much water
can cause the paint
to become too dilute.

Brushes for use
with white paint

Use fine brushes like a
mensofude (thin brush used to
render facial features) or a
hakkei (ultra-fine *mensofude*).

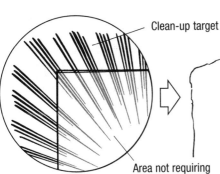

Place some paint
in a small dish.

Add water.

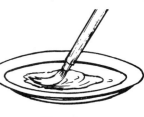

Mix well.

Clean up lines sticking beyond boundaries, etc.

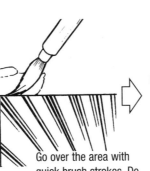

Clean-up target

Area not requiring
correction

Go over the area with
quick brush strokes. Do
not rub the paper.

Cleaned-up image

- As water-based white
 paints age, they begin to
 dry out and become
 difficult to apply.
- The Misnon brand uses a
 special liquid that easily
 damages the brush.
 *Once you have finished
 using the paint, wash the
 brush well.
- Mistakes made with
 water-based technical
 pens and felt-tip pens are
 difficult to correct.
 *Use an oil-based
 product to correct water-
 based materials.

Using White for Special Effects: Adding Highlights to Eyes

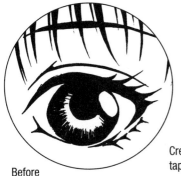

Before

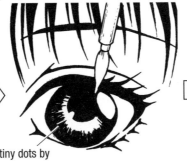

Create tiny dots by
tapping with a brush.

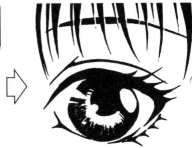

After/Final image

*Oil-based products consist of correction pens, white ink pens, and liquid paper.

Hikaru Hayashi

1961 Born in Tokyo.

1986 Graduated with a degree in the Social Sciences and Humanities from Tokyo Metropolitan University with a major in Philosophy.

1987 Received a hortative award and honorable mention for his work on Shueisha Inc.'s *Business Jump* and served as assistant to Hajime Furukawa.

1989 Worked on Shueisha's *Shukan Young Jump* while apprenticing under Noriyoshi Inoue.

1992 Published his debut work based on a true story, "*Aja Kongu Monogatari*" ["The Story of Aja Kong"] in *Bear's Club*.

1997 Founded the *manga* design and production studio, Go office. Produced illustrations for the works *Butsuzo ni ai ni iko* [on the appreciation of Buddhist sculpture] by Hiromichi Fukushima (published by Tokyo Bijutsu Inc.)

1998 Authored *How to Draw Manga: Female Characters*, *How to Draw Manga: Male Characters*, *How to Draw Manga: Couples*, and *How to Draw Manga: Illustrating Battles*.

1999 Authored *How to Draw Manga: Bishoujo around the World*, *How to Draw Manga: Bishoujo/Pretty Girls*, *How to Draw Manga: Occult and Horror*, and *How to Draw Manga: More about Pretty Glas* ; promoted, produced, and wrote the *manga* copy for Koki Ishii's *Kokuhatsu manga riken retto* (book on the wasteful spending of Japanese politicians), published by Nesco Co., Ltd.; and produced the corporate identity mascot character for Taiyo Group driving school.

2000 Authored *How to Draw Manga: Animals* ; produced and initiated the release of *Bishoujo Fighting*, a *dojinshi* (fanzine or small press comic) for pro wrestling fans under the name of Meto (a fanzine specializing in woman's wrestling and cat fight videos, published biannually when matches occur; fifth issue on sale as of 2002).

2001 Coauthored *How to Draw Manga: Martial Arts and Combat Sports*, *How to Draw Manga: Giant Robots*, and *How to Draw Manga: Costume Encyclopedia, Everyday Fashion*.

2002 Coauthored *More How to Draw Manga Vol. 1* and *How to Draw Manga: Costume Encyclopedia, Intimate Apparel*, published by Graphic-sha. Mr. Hayashi continues the planning and production of original Go Office fanzines.

Rio Yagizawa

Ms. Yagizawa was born in Tokyo on January 8. She is a Capricorn with an A blood type. She first started doodling in pencil in nursery school and made her first attempt at drawing *manga* in pen during the fifth grade. In junior high, she began to produce *doujinshi* type *manga* works with friends from upper grades and in her class.

In 1981 she debuted as an illustrator with Minori Shobo's monthly publication, *Gekkan OUT*. She acted as an illustrator, an aniparo (animation parody) and *manga* artist, an anime writer, etc., contributing illustrations to Minori Shobo's Aniparo Comics, Akita Publishing's *My Anime*, Tokuma Shoten's *Animage*, etc.

In 1986 she debuted as a full-fledged *manga* artist in Kobunsha's Comic Val. Since then, she has contributed series and single publication works to Kobusha's *Pretty*, as well as cover and page illustrations for paperback editions targeted toward young readers published by Seishinsha, Kadokawa Shoten, Shogakkan, and other publishers. She has authored 9 *manga* volumes and illustrated more than 25 paperback books.

In 1998 she began to participate on the production side with Graphic-sha and Go Office, starting with *How to Draw Manga: Couples* and continues such efforts today.

Go Office Profile ————————————————————————

Go Office was founded in May 1997 and has been specialzing in the production of tutorial resources using *manga* and illustrations, which include publications on *How to Draw Manga* series.